MILLET

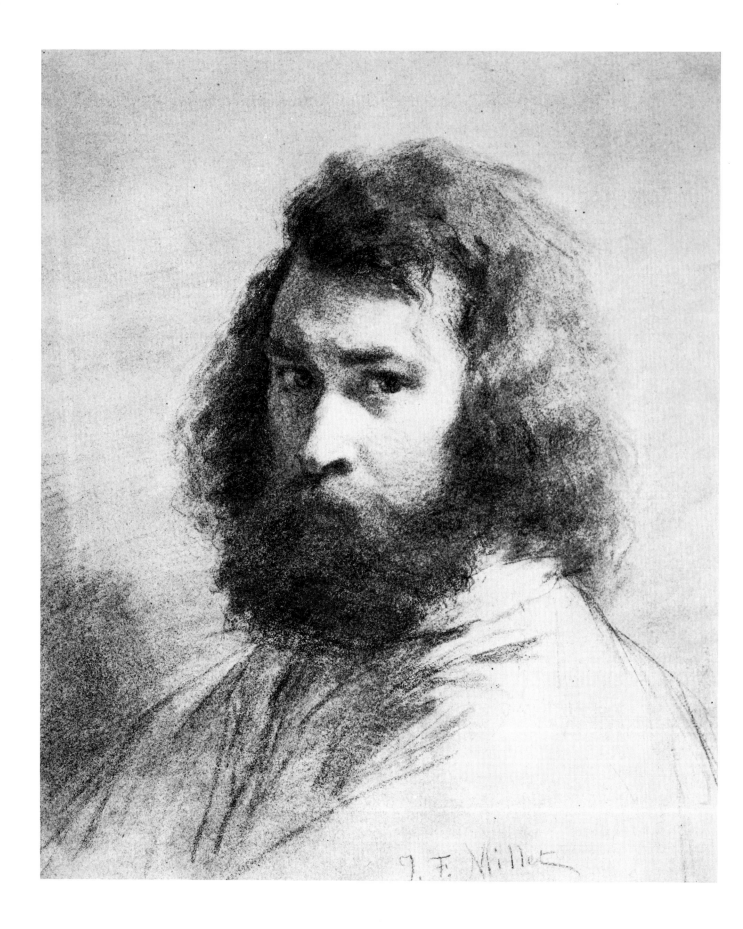

MILLET

GRISELDA POLLOCK

(frontispiece)
Self-portrait
PARIS, Musée du Louvre, Cabinet des Dessins. 1845–46. Drawing on grey-blue paper 56·2 × 45·6 cm.

This self-portrait, drawn four years later than Plate 1, illustrates a significant shift in the artist's self image, from bourgeois to bohemian, which was completed in yet a later self-portrait of 1847–48 (Paris, Musée du Louvre) in which the artist appears in working clothes and a woollen hat, sports a massive beard and conveys an air of impenetrable and saddened self-containment. The drawing of 1845–46 is a fine example of the subtlety of Millet's draughtsmanship in which modulations of tone alone establish volume and structure, texture and mood. Despite the force of the dominant head, fulsome beard and unkempt hair, a certain gentleness pervades the whole, highlighted in the contrast of the bony forehead and the trailing lock of hair which delicately falls across it. Millet presented himself with solid masculine force while revealing an emotional and pessimistic disposition, a combination underlined by the partnership in the drawing itself between a sense of volume and structure and the sensuous feel of the medium.

ACKNOWLEDGEMENTS

Anyone attempting to write about Millet owes an enormous debt to Professor Robert Herbert of Yale University whose pioneering work has stimulated a re-assessment of Millet through numerous articles. He organized the first major modern exhibition of the artist's work in Paris and London in 1975–76 and is at present preparing the definitive catalogue raisonné of Millet's *oeuvre*. No-one writes alone. There are many friends who have helped me with their comments, patience and critical interest. Some need particular acknowledgement: Ruth Pavey, for reading the drafts and discussing them with me and for support while writing; Anthea Callen, who has taught me so much about paintings and has shared with me her important ideas on the enormous significance of techniques in the nineteenth century; Fred Orton, who opened my eyes to van Gogh and thus indirectly to his master, Millet; John Glover, who has analysed Millet's use of geometry and suggested many new lines of enquiry; and Mrs. Hoogendyck, who transformed my initial scribblings into an excellently typed manuscript at short notice and with infinite pains. The editor always seems to come last, but my thanks are no less to Robert Oresko, who encouraged the book from the start and me in the writing of it and did so much work to produce it in its final form. I want also to thank Elizabeth Kent for her arduous task collecting the illustrations.

Sincere thanks are also due to the following for their help in providing photographs and information: Albright-Knox Art Gallery, Buffalo; Art Institute of Chicago, Chicago; Ashmolean Museum, Oxford; Bibliothèque Nationale, Paris; Brancacci Chapel of the Carmelite Church, Florence; British Museum, London; Carlsberg Glyptotek, Copenhagen; City Art Gallery and Museum, Glasgow; City Art Gallery, Plymouth; Cleveland Museum of Art, Cleveland; Corcoran Gallery of Art, Washington; Ets. J. E. Bulloz, Paris; Fogg Art Museum, Cambridge, Massachusetts; Kunsthalle, Bremen; Metropolitan Museum of Art, New York; Minneapolis Institute of Arts, Minneapolis; Tom Molland; Musée Bonnat, Bayonne; Musée des Beaux-Arts, Dijon; Musée Condé, Chantilly; Musée du Louvre, Paris; Musée Thomas Henry, Cherbourg; Museum of Fine Arts, Boston; National Gallery of Canada, Ottawa; National Museum of Wales, Cardiff; Philadelphia Museum of Art, Philadelphia; Provident National Bank, Philadelphia; Rijksmuseum Kröller-Müller, Otterlo; Rijksmuseum Mesdag, The Hague; Service de Documentation Photographique de la Réunion des Musées Nationaux, Paris; Toledo Museum of Art, Toledo, Ohio; Victoria and Albert Museum, London; Walsall Art Gallery, Walsall; and Yale University Art Gallery, New Haven.

To Alan, my father

First published in Great Britain by
Oresko Books Ltd., 30 Notting Hill Gate, London W11
Copyright © Oresko Books Ltd. 1977

This edition published by Universal Books Ltd.,
The Grange, Grange Yard, London SE1 3AG
UK ISBN 0 905368 12 6 (cloth)

and Park South Books, an imprint of Publishers
Marketing Enterprises Inc. 386, Park Avenue South,
New York, New York 10016
USA ISBN 0 917923 14 6

Printed in Spain by Jerez Industrial, S.A.

Jean-François Millet

I

Millet was truly a peasant-painter; for he was the son of a peasant, lived the greater part of his life amongst the peasant class, and was accustomed to dress usually as if his only occupation was to tend the sheepfold and help in the garnering of the harvest.

Art Journal obituary, 1875, p. 108

I would not terminate this list and address myself to landscape painters without cheering the arrival among us of a great artist, who in the sabots of a peasant, treads in the footsteps of Michelangelo and Lesueur.

E. About, review of French Exhibition 1855, quoted in *Art Journal*, 1875, p. 188

Watching a rustic family occupied with the labour of the fields, the anxious spirit, the air of resignation, the slow and laborious gestures, one returns to Millet and the man of understanding will say: here is a painter who gives life to the humble, a poet who exalts ignored splendours, a good man who encourages and consoles.

Alfred Sensier, *Jean-François Millet, paysan et peintre,* 1881, p. xi

Le Figaro has just published two letters by the great Millet: These letters clearly show the painter in a particular light and clearly indicate the petty side of this great man. It is very discouraging. . . . Because of the *Man with the Hoe,* the socialists thought Millet was on their side assuming that this artist who has gone through so much suffering, this peasant of genius who had expressed the sadness of peasant life, would necessarily be in agreement with their ideas. Not at all. . . . I was not much surprised. He was a bit too biblical. Another of those blind men, leaders or followers who, unconscious of the march of modern ideas, defend the ideas without knowing it despite themselves.

Camille Pissarro to his son Lucien, 2 May 1887

My general thesis therefore, perhaps surprisingly at first glance, is that the peasant was among the most important subjects for the embodiment of the artist's attitudes toward the urban-industrial revolution. . . . I will write most often of Jean François Millet (1814–1875). He has been known as the 'peasant painter' since the 1850s and any interpretation of peasant art would have to be measured against his work.

Robert Herbert, 'City vs. Country: The Rural Image in French Painting from Millet to Gauguin', *Art Forum,* February 1970, p. 44

THE CENTRAL PROBLEM in the work of Jean-François Millet (1814–1875) is how and why he made the peasant and agricultural labour the subjects of his life's work. The statements quoted above reflect the various and often contradictory interpretations that Millet invites. When we look at his images of peasants we wonder whether we are in a world of Virgilian pastorals and Dresden shepherdesses or confronted with the painted convictions of a humanitarian socialist. He has been seen as a philosophical pessimist contemplating the inevitable fate of man since Adam was expelled from the garden of Eden, the voice of the oppressed peasant or the eulogist of the rural idyll. Millet, more than any other major painter of the nineteenth century, has, by turns, inspired and offended, baffled and attracted his critics and admirers, to such an extent that any writer can only hope to add another chapter to an ongoing debate.

To begin with, his basic reputation has never been secure. During the 1850s and 1860s his work met with hostile criticism, but he survived with the devoted support of friends like Sensier and Théodore Rousseau and a small band of enthusiastic collectors. But in 1887 the establishment that had left him out in the cold during his lifetime honoured him with a major retrospective exhibition at the Ecole des Beaux-Arts, the very institution at which he had failed in his youth and which he had abandoned to make his own way in 1839. By the 1880s, however, progressive artists outside the Ecole were deriving inspiration from his works. Camille Pissarro (1830–1903) himself had clearly been influenced by Millet's subject matter (fig. 1), and in another letter to his son Lucien, after seeing the big 1887 show, had written that 'Millet's chief value lies in his drawings.' It was Millet's draughtsmanship again that profoundly touched the young Neo-Impressionist

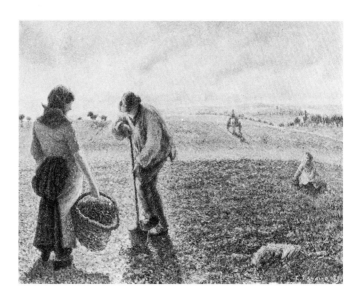

fig. 1 Camille PISSARRO
Peasants in the Fields
Oil on canvas 63 × 77·5 cm. 1890. Buffalo,
Albright-Knox Art Gallery (gift of A. C.
Goodyear)

Both the subject matter of peasants digging
potatoes and the central figures of the man
and the woman owe a direct debt to Millet,
especially to such pictures as *Going to Work*
(Plate 22), *The Angelus* (Plate III) and
Planting Potatoes (Boston, Museum of Fine
Arts). Pissarro also painted shepherdesses and
goosegirls which have precedents in Millet.

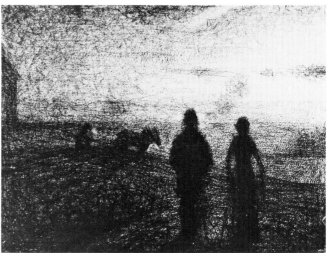

fig. 2 Georges SEURAT
Ploughing
Conté crayon on paper 27·5 × 32 cm. 1882.
Paris, Musée du Louvre, Cabinet des Dessins

Millet exercised a profound influence on the
work of the young Seurat both in the choice of
peasants working in the fields as subject matter
and notably in his drawings in which the
medium itself was used to conjure up the time
of day and create a palpable atmosphere.
Other Seurat drawings directly influenced by
Millet contain specific references to Millet's
titles, such as *Twilight* of 1883 (Paris, Galerie
Berggruen) and *The Man with a Spade* of 1883
(private collection).

Georges Seurat (1859–1891), who experimented with
Millet's use of crayon to produce enveloping atmo-
spheres of twilight (fig. 2). Vincent van Gogh (1853–
1890), perhaps Millet's greatest disciple, wrote to his
brother in January 1884, 'I consider Millet, not Manet
to be the essentially modern painter who has opened a
new horizon to many.'

In the latter decades of the nineteenth century, how-
ever, Millet's works were widely collected in the circles
most opposed to the developments of modern art, while
his general reputation sank under the weight of his sup-
posed sentimentality. Yet, as Robert Herbert has shown
(Herbert, 1970), it was in these very decades too that
Gauguin, Seurat, van Gogh and later artists in the
Fauve and early Cubist groups were using the peasant
image as a symbol of sincere, unsophisticated, primitive
and regenerative forces, laying the foundation for the
use of the agricultural worker as the representative of
revolutionary societies. Thus Millet can be linked to the
advanced tendencies in modern art at the turn of the
century.

No interpretation of Millet is more stimulating or
original than that of the Surrealist painter, Salvador
Dali (b. 1904), who became obsessed by Millet's *The*

Angelus (Plate III), producing several erotic paintings
of it, such as *Atavism of Twilight* (Switzerland, private
collection, 1933) and *Homage to Millet*, an illustration
in a 1934 edition of Lautréamont's *Chants de Maldoror*,
and devoting to it an essay in his singular style of
criticism, 'la paranoïaque-critique', in which he ignored
the naturalism, rural lyricism, or political implications
which had been the substance of criticism to date. In-
stead, inspired by the psychoanalytic work of Freud, by
Jung's explorations of myths and by his own interest
in folklore, he saw in *The Angelus* a reflection of the
great myths of fertility and cycles of life and death re-
presented by the archetypes of woman and the earth
and the dusk.

In the last two decades, Millet has once again at-
tracted serious scholars and apologists, the foremost of
whom is Robert Herbert, whose scholarship and en-
thusiasm have revised many of the most pejorative
views of Millet and created the interest from which
this book itself is being written.

Thus Millet is by no means an easy artist. In the
catalogue for an exhibition to celebrate Millet's 150th
anniversary, Lucien Lepoittevin (Lepoittevin, 1964)
entitled his essay 'la dialectique des contraires', the

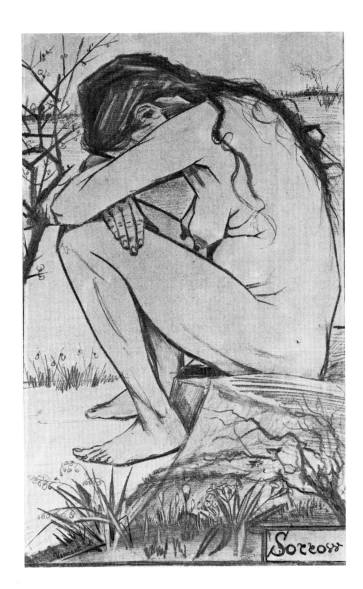

fig. 3 Vincent van GOGH
Sorrow
Black chalk 44·5×27 cm. 1882. Walsall,
Walsall Art Gallery (Garman-Ryan collection)

Van Gogh may perhaps be considered Millet's greatest disciple, for his admiration of Millet was boundless and his pictorial debt profound. However, this outline drawing of a huddled, pregnant nude is the most atypical of van Gogh's studies of Millet. But for the very reason that it is not concerned with rural subject matter nor lumpy paint, it reveals the Dutchman's real understanding of Millet in the latter's use of expressive silhouette in which the burden of meaning is laid on the pose of the total figure. *Sorrow* furthermore illustrates the breadth of van Gogh's knowledge of Millet for he had seen the exhibition of Gavet's pastels and drawings in 1875 at which Millet's draughtsmanship was revealed publicly for the first time.

dialectic of opposites. Such oppositions are as varied as conservative/socialist, peasant/alienated intellectual, romantic/classicist, realist/idealist. It is perhaps to his contemporaries and followers that we should turn for insights into these paradoxes, for instance Pissarro's letter, quoted above, which clearly identifies some of the central ones, the 'peasant of genius' expressing 'the sadness of peasant life', the 'biblical' tendencies of a personality none the less touched by 'modern ideas'.

Millet had been born a peasant in Gruchy in Normandy in 1814 and spent most of his life between 1849 and 1875 in a small village on the edge of the Forest of Fontainebleau. Yet he was also one of the most highly educated artists of the nineteenth century. He had been tutored by the local curé and learnt to read the Bible and Virgil in Latin. When he came to Paris at the age of twenty-three he spent his time in the Bibliothèque Ste. Geneviève reading Vasari's *Lives of the Painters* and the letters of his fellow Norman, the seventeenth-century classical artist Nicolas Poussin. He spent months in the Louvre acquiring an extensive knowledge of the art of the past, from classical statuary to his immediate French forbears.

Paintings like *Man with the Hoe* (Plate 29) aroused the political sympathies of the critics. Left-wing writers claimed him as the painter of the 'Modern Demos', while conservatives decried the brutal picture of bestial humanity painted with what Théophile Gautier called 'masonries of paint'. Against both interpretations Millet was defended by his friend and biographer, Alfred Sensier, who offered instead a picture of a man of deep piety and filial duty, more dedicated to the representation of the biblical injunction to Adam and Eve to 'earn their bread by the sweat of their brow' than concerned with attempts to order more egalitarian distribution of both bread and sweat. And yet, as Robert Herbert has pointed out (Herbert, 1976), Millet provokingly continued to produce works which invited political interpretation despite the critical abuse and hardship he encountered as a result.

The evidence of his work, however, undoubtedly places Millet in the mainstream of modern ideas. He had personal experience of the widespread social phenomenon of the move away from the land when he abandoned the life of a peasant to become a professional painter in Paris. His return to the country with his retreat to Barbizon in 1849 also conforms to a broader pattern. Artists such as Théodore Rousseau (1812–1867) and Charles Jacque (1813–1894) also made Barbizon their home, while Millet's choice of subject matter, peasant and landscape, finds parallels in the work (fig. 6) of his contemporaries, notably Gustave Courbet (1819–1877).

The economic, social and political upheavals of the nineteenth century, the 'Age of Revolutions', dislodged traditional structures, institutions, authorities, hierarchies, ideologies and belief systems. This process can be seen distinctly in the cultural sphere, and for a time in France in the 1840s political and artistic revolutions seemed to run in parallel.* In the wake of the popular

* The best and most stimulating study of this interaction is T. J. Clark's two books *The Absolute Bourgeois* (1973) and *The Image of the People* (1973).

uprising in Paris in February 1848, which displaced the monarchy and established a republic, the official jury was abolished and the annual exhibition at the Salon became absolutely free. Here it was, for instance, that Millet exhibited *The Winnower* (U.S.A., private collection), a single large-scale peasant subject which prefigured his mature style and subject matter of the 1850s. In the light of this intensely political atmosphere it is not surprising that contemporaries with political beliefs such as those of the anarchist Pissarro or later historians with radical sympathies should want to interpret Millet in the context of nineteenth-century upheavals. But the contradiction that Pissarro himself observed between the biblical Millet's denial of socialist intentions and his undeniably disturbing works demands a more subtle explanation. For how does one account for the fact that by 1887, the date of Pissarro's letter, Millet was acceptable to the artistic and social establishment? One need only glance at the location of many of his paintings, by this time in the homes and offices of industrialists and rich collectors in France, England and America, where the toil-wearied figures of the peasantry calmed rather than troubled the serenity of modern capitalist man.

The process of history is dynamic so that the peasant, dangerous and explosive in 1848 in the extreme turmoil of revolution, could become the supreme symbol of natural and eternal Man, located outside History in Nature, once the new order had emerged stable and triumphant. One writer has characterized the ideology* of the bourgeoisie as exactly that inversion of History and Nature:

The status of the bourgeoisie is particular, historical; man as represented by it is universal, eternal. The bourgeois class has precisely built its power on technical scientific progress, on an unlimited transformation of nature; bourgeois ideology yields in return an unchangeable nature.

Roland Barthes, *Mythologies*, 1972, pp. 141–142

The manner in which the artist relates to History and Nature (Society) is equally a dynamic one in which various levels of consciousness interact with the forms and the conventions of his medium. Max Raphael has nicely defined this process:

For the very reason that in art the human mind neither imitates nature nor imposes its own laws absolutely upon it, the work of art possesses a specific reality and is governed by laws of its own.... Whatever form art may assume in the course of history, it is always a synthesis between nature (or history) and the mind and as such it acquires a certain autonomy vis-à-vis both these elements. This independence seems to be created by man and hence to possess a certain psychic reality; but in point of fact the process of creation can become an existent only if it is embodied in some concrete material. This material, though the product of the action of society upon nature, at the same time makes possible a record of the gratification of our intellectual and emotional needs in a form characterised by inner necessity.

Max Raphael, *The Demands of Art*, 1968, p. 10

If we take our cue from these quotations we can formulate the problem of Millet, 'the peasant painter', by investigating the meaning his peasant origins and assumed lifestyle after 1849 had for his art. What were his intellectual and emotional needs? What purpose did his monumental and consoling images of agricultural labour serve for the artist or his contemporaries? How did nature and mind interact? Finally, how did his personal experience and consciousness of contemporary events find expression in actual paint on canvas and crayon on paper?

The fact that Millet was born on the land is the single most important factor in his life and work, for by realizing the full significance of it, one can resolve most of the contradictions. Millet knew the land and its labours, its seasons, moods and forces. He knew the peasant's attitude to life and work. He knew what it meant to leave the land. He later returned to it. He expressed his aims in life and art in agricultural metaphors and consciously reassumed the peasant lifestyle with characteristic truculence and pride, burdened by a fatalistic and resigned outlook on life. If we listen to his words, and to those of others who shared that disappearing consciousness, we can reconstruct his experience and enter his work.

Jean-François Millet was born in Gruchy, Normandy, on 4 October 1814, the eldest son and second child of a peasant family which worked its own land. The peasant class in France at this time was by no means homogeneous nor necessarily backward. The artist's father was a gifted organist and calligrapher, and no doubt both Millet's own feeling for a beautiful hand and his fine use of the pencil or crayon as the medium of plastic expression were derived from his father. His grandmother, Louise Jumelin, came from an interesting family in which one brother became a doctor of medicine and published scientific papers, a second did a world tour, another was a curé and the fourth was a miller with a passion for the literature of the sixteenth and seventeenth centuries, especially Montaigne and Pascal. Millet's mother came from so prosperous a peasant family that they were considered gentry in the area.

Millet's own intellectual interests and his family's encouragement of them should not surprise us in this context. He was sent to the local school, where the curé, recognizing his exceptional abilities, tutored him in the then essential qualification for entry into the professions, the mastery of Latin, with which he could have followed either of his great-uncles into the Church or medicine. He read widely—Chateaubriand, Byron, Scott, Goethe, Hugo, Shakespeare, Milton and Dante—but in his youth his greatest loves were the Bible and Virgil's *Georgics*, both full of the poetry of the land and its cultivation. Millet's education, therefore, though

* Ideology has been defined as 'a lived-relation between men and their world, or a reflected form of this *unconscious* relation, for instance a "philosophy"'. Pissarro was extremely perceptive, therefore, when he recognized the possibility of an unconscious and unintended participation by Millet in 'the march of modern ideas', the emerging bourgeois ideology.

perhaps more extensive than that of many of his social class, was not exceptional. Far from being antipathetic to his sense of being peasant, familiarity with works of art of a pastoral genre helped provide a form to express it.

His early interest in drawing, encouraged no doubt by his father, was taken sufficiently seriously by his family for his attempts to be shown to Mouchel (1807–1846), a local artist in Cherbourg. Millet's earliest extant efforts established the rustic bent of his mature work. One drawing showed shepherds playing the flute under a tree. The figure of the shepherd, 'an enigmatic character, a mysterious being' (Sensier, 1881, p. 120), fascinated Millet all his life (Plates 38 and 48). Another drawing was of a semi-religious nature, an act of charity set significantly beneath a starry night sky, revealing from this very early date Millet's sensitivity to times of the day and atmosphere (Plates 41–43, 48, 61, 66 and above all *Starry Night*, Plate IV).

Despite the encouragement of Mouchel and later that of a second teacher, Langlois (1803–1846), Millet still vacillated between studying art in the museum at Cherbourg, which had just received a superb donation of Old Master paintings, and working on the land as befitted the eldest son of a growing family. When his father died in 1835 he returned briefly to the farm to take up his rôle, but in 1837 he finally left for Paris with a municipal scholarship in his pocket.

Rural depopulation by emigration to the towns was fast becoming a cause of great concern; the population of Paris rose by only 1·5% between 1790 and 1831, but between 1831 and 1851 it doubled in size, with no appreciable rise in the birth-rate to account for it. The cause was emigration from the land, which was becoming so severe that national institutions sponsored competitions on the subject, such as the one which Eugène Bonnemère won from the Nantes Académie in 1846 with an essay entitled 'The Causes of Emigration from the Countryside and the Ways of Stopping It'. Millet began a trend away from the land in his family which meant that on the deaths of his grandmother and mother in 1851 and 1853 respectively the home farm was left without sons to carry on the work. (Both his brothers eventually joined him in Barbizon.) The probable guilt he felt, coupled with nostalgia for what had been left behind, was a potent source of feeling that resonates throughout Millet's later work and justifies Sensier's term 'an art of consolation'.

In 1837 Millet arrived in Paris, as had so many a peasant in the history of nineteenth-century waves of immigration, a 'greenhorn'. The description of his feelings of isolation and ignorance, given to his biographer, Sensier, emphasized the reality of peasant consciousness and the gap between it and that of the city:

And Paris, black, muddy, smoky where I arrived one evening was for me a most painful and discouraging experience. It was a Saturday in January that I arrived in the evening and it was snowing—A wave of sobs overwhelmed me which I could not stop. I wanted to be stronger than my feelings but they totally overcame me. . . . Paris appeared dull, dreary and stale. I went to a cheap hotel and spent my first night in a sort of continual nightmare in which I saw my home full of melancholy, with my mother, grandmother and sister spinning in the evening and thinking of me, weeping. . . . It was thus that I encountered Paris without wishing to think ill of it but with the terror born of incomprehension of either its material or spiritual life.

Perhaps we today are too accustomed to urban life to appreciate the full force of its alien quality to a man reared in a small country community. Like so many immigrants, Millet wandered aimlessly through the strange streets, gauche and bewildered. He searched for the 'old museum' (the Louvre), not risking ridicule from strangers by daring to ask the way, until by chance he found himself on the Pont Royal opposite what turned out to be the museum into which he rushed to find comfort in the familiar company of the Old Masters.

In an essay on the urban phenomenon, *Soft City* (1973), Jonathan Raban devotes a chapter to the experiences of the 'greenhorn' and quotes this ironic description of one such arrival in New York in the early 1900s:

All morning he walked the streets of Brooklyn, not a little confused by the traffic and turmoil. His wooden shoes clattering on the pavement added to the noise, and passers-by, amused, paused to grin at him. This suffused him with a pleasant glow. People seemed very kind in America.

This passage echoes what Millet experienced, but he accustomed himself slowly. 'Finally I took root and my homesickness for the country weakened its hold a bit', he confided in a letter to Sensier. Paris was never very kind to him while he lived there on and off during the next decade, struggling with poverty, nursing his dying wife in a sordid rooming house. As an artist he was unsuccessful, but he made some money by painting signs and saleable nudes, while he lived in a garret with a servant girl from Cherbourg with a growing illegitimate family, totally cut off from home by his deviation from conventional peasant morality.

His obvious and delighted response to his arrival in Barbizon, near Fontainebleau, in 1849, provides a pointed contrast to his description of Paris. He wrote to Sensier in 1849:

If you could see how beautiful the forest is! I sometimes rush out into it at dusk, after my day's work, and every time I come back feeling overwhelmed. Its calm and stateliness are terrifying. . . . Tomorrow, Sunday is the Barbizon fête. Every oven and stove and chimney, every pot and pan is so hard at work that it might be the day before the marriage at Cana. Even old curtain rods are doing duty as spits, and all the turkeys, geese, chickens and ducks, that you saw in such robust health are being roasted etc. or being made into pâtés the size of cartwheels! In short, Barbizon is one huge kitchen and the smells must be drifting far and wide.

Barbizon came more and more to be Millet's home, and returning from a visit to Normandy in 1854 he exclaimed to a friend, 'Barbizon! Barbizon! O how much I feel more and more a countryman.' Millet felt acutely that Romantic love of place which he shared with

another country-born artist, John Constable (1776–1837).

Normandy, his native soil, however, never faded from his memory. His first works in Barbizon, like *The Sower* of 1850 (Plates 19 and 20), were set on the steep hillsides of Gruchy rather than on the plains of Chailly (Plates 21 and V). His visits to Normandy produced statements like 'O once more such a feeling! How much I belong to this place', in addition to paintings of the village of Gréville (Plate 59), the church at Gréville (Plate VI) and the remembered tasks of the people of that area (Plates 34 and 66).

His personal love of a specific place took on a more generalized form when translated into art. Here Millet's education, his familiarity with the literature of the pastoral from Virgil and the Bible enabled him to make transitions from biography to the universal, or, perhaps, to hide his private experience in the language of public forms. In 1851, for instance, he began a painting entitled *Ruth and Boaz* (Plates 23 and 24), a biblical story which shows the well-to-do landowner introducing the poor, shy and charmingly recalcitrant gleaner Ruth to the honest harvesters. The final oil, entitled *Harvesters Resting*, shedding its biblical theme, was felt by Moreau-Nélaton (1921) to be a veiled piece of autobiography, in which Millet wishfully introduces his lower-class mate (Plate 14), with whom he lived unmarried until 1854, to the honest community of his home. Through a fictional scene guilt was resolved, while significantly Millet chose to present himself in a rustic persona and his dilemma in a rural setting.

But the experience of being a peasant runs deeper. Julia Cartwright (1904) quoted Millet in a phrase which transcends the particular and reflects a belief in the eternal regenerative power of the earth itself, 'O the earth! the earth—there is nothing but the earth. There, there is no death.' Millet looked for consolation and faith to the rhythms of life and death in the earth's cycles and seasons. He wrote to Sensier:

O I wish I could make those people who see my work feel the terrors and splendours of the night. One ought to be able to make them hear the songs and murmurings of the air. They should feel the infinite. Is there not some thing awesome in the thought of these lights which rise and fade century after century without change? They light both the joys and sorrows of men and when our world begins to crumble, the beneficent sun will watch without pity our universal desolation.

Millet's writings are usually said to betray a profound pessimism. He told Théodore Rousseau that, like Dante, he felt our time on earth was the 'time of our debt'. He was of a melancholy temperament for life treated him harshly, but the real roots of his philosophy of life lay more in a kind of fatalism, with which innumerable writers, then and since, have characterized the peasant mentality, while rarely understanding it. The peasant witnessed the harsh reversals of nature's forces* as well

as its beneficence. He experienced life cyclically, with a special understanding of processes of change and time. The most extensive statement of Millet's outlook survives in a letter of 1854, in which he described three treatments of peasant women:

But to tell the truth, these [three studies] suit my temperament best, for I must confess at the risk of being taken for a socialist, that it is the treatment of the human condition** that touches me most in art. . . . For I never see the joyous side; I do not know where to find it for I have never seen it. The happiest thing I know is the calm and the silence one so deliciously experiences in the forest or in the fields. You will admit that it is always dreamy, a sad dream, though painfully pleasurable.

You are seated beneath the trees, enjoying a sense of well being and tranquillity, you see emerging from a small path a pitiful figure burdened with a faggot, the striking and unexpected appearance of this figure takes you back instantaneously to the sad fate of man, *Weariness*. . . . It reminds me of what La Fontaine expressed in his fable of the Woodcutter,

What pleasure has he had since the day of his birth?
Who so poor as he in the whole wide earth?

Millet subsequently painted this exact subject (Plate 27) and depicted the weariness of the faggot bearer (Plates 39 and 71).

By comparing the two self-portraits (*frontispiece* and Plate 1) one can see how Millet, once the aspiring city artist, consciously reassumed his peasant identity during the 1840s. In 1853 he visited the great 'dandy' of French art, Eugène Delacroix (1798–1863), who confided to his diary on 16 April with revealing aristocratic disdain that

This morning Millet was brought to see me. He talked of Michelangelo and the Bible, the only book, more or less, which he reads. That explains the slightly pretentious appearance of his peasants. Indeed he himself is a peasant and boasts of it.

Moreover, the very language Millet used to explain himself was couched in agricultural metaphors. His defensive pride was aroused in 1859 by a hostile criticism of his work by the 'Gentlemen of the Salons':

They think they can tame me, that they can impose on me the art of the Salons, well, NO! Peasant I was born and peasant I shall die. . . . I shall stand my ground and not withdraw one sabot.

A further reflection of Millet's identification with peasant values can be seen in another quotation from the artist:

My programme is work because every man is vowed to physical labour: 'you shall live by the sweat of your brow', so it is written from time immemorial; an eternal destiny which will not change. What every one should do is to seek to make progress in his profession, to apply oneself unceasingly, to become strong and skilled in one's trade, to surpass one's neighbour by one's talent and conscientiousness. This is my only path—the rest is moonshine or contrivance.

Such statements have been dismissed in the past as part of Sensier's romantic and hagiographical fabrication of Millet's saintly character. Alternatively they could be said to resound with echoes of the bourgeois ethic of

* For Millet's account of a furious storm he witnessed as a child and its effect on him, see A. Sensier, *J.-F. Millet* (1881) pp. 29–32.

** 'Le côté humain' is difficult to translate. Littré (1954) gives these three definitions of 'humain': (1) that which concerns man, humanity; (2) sensitive to pity; (3) human nature. In a combination of these nuances Millet's meaning emerges.

hard work and self-improvement celebrated by the English artist Ford Madox Brown in *Work* (Manchester City Art Gallery, 1855), a painting inspired, however, by the great nineteenth-century philosopher, Thomas Carlyle, in whose influential text *Past and Present* (1843) occurs the phrase 'Blessed is he who has found his work.' It is more than a coincidence that Carlyle himself was a Scottish peasant by birth. Millet's statements, as recorded by Sensier, are not an untrue reflection of the artist. Millet could have chosen to rise into the bourgeoisie, become a classical and respectable painter, like his teacher in Paris, Delaroche, but he turned his back on that world for many reasons and went to Barbizon where his important childhood experiences were, perhaps unconsciously, allowed to fertilize and give conviction to his art.

Nowhere is this process clearer than in the Boston version of his great *Sower* of 1850 (Plate 19), his first successful and distinctive peasant subject. A strong young peasant strides manfully down the incline scattering his precious seed, the bread of the future. The Michelangelesque cast of the figure elevates it beyond mere 'genre' to the seriousness of a history painting. Its title recalls the biblical parable in which the seed symbolizes the seed of Truth. When the subsequent version of *The Sower* was exhibited (Plate 20), Gautier wrote that it seemed to have been painted with the very earth the sower was sowing. The mythic quality of the picture lies in the very substance of the soil, symbolized by the artist's material, paint. Perhaps, too, this work allows a biographical reading, an assertion in oil on canvas of the life and programme Millet was to follow after 1849 when he left Paris. Millet's consciousness of being born a peasant thus gives new significance to the choice and treatment of his subjects from 1850 to his death in 1875.

II

Just think this one over and see whether you don't agree. They started with a peasant's and labourer's figure as 'genre', but at present, with Millet the grand master as leader, this is the very core of modern art.

Vincent van Gogh, July 1885, *Complete Letters*, 1959, vol. II, p. 403

Millet once again, the painter of an entire race and the environment it lives in.

Vincent van Gogh, July 1888, *Complete Letters*, 1959, vol. III, p. 506

But with the materiality of the earth, the substance itself affords so many actual experiences, its form is so full, so evident, so real, that one can scarcely perceive how to give bodily substance to the rêveries that touch the deepest parts of matter. As Baudelaire once said: 'The more matter appears actual and solid, the more subtle and difficult is the task of the imagination.'

Gaston Bachelard, *La terre et les rêveries de la volonté*, 1948, p. 3

I believe he failed because the language of traditional oil painting could not accommodate the subject he brought with him. . . . There is no formula for representing the close, harsh, patient physicality of a peasant's labour *on*, instead of *in front of* the land. And to invent one would mean destroying the traditional language for depicting scenic landscape.

John Berger, *New Society*, 29 January 1976, p. 230

MILLET'S CAREER AS an artist coincided with dramatic developments in the history of nineteenth-century art. The dominant styles of the first half of the century, Romanticism and Neo-Classicism, were losing conviction, while a new historical consciousness of the art of the past emerged in the form of rapid reversals of taste and revivals of long-forgotten or unvalued artists and periods as, for instance, the interest in Italian Primitives, eighteenth-century French art, seventeenth-century Dutch art and French painters like the Le Nain brothers (fig. 4).*

For young artists seeking to make their way, there existed what could be called a crisis of style. The Goncourt brothers described how a number of brilliant and ardent young artists developed and, in the twilight of Romanticism, moved around from the influence of one master to another, trying to fuse certain qualities and producing 'a bastard eclecticism and a style lacking conviction or ease'. Millet's work during the restless decade of the 1840s conformed to this pattern as he experimented with subject and style, moving between portraits (Plates 2 and 3), pastorals in the manner of Fragonard (fig. 5 and Plate 6), gently erotic themes (Plates 4 and 7), religious and classical subjects (Plate 5) and more rustic genre (Plates 8–12). His tastes and sources were as eclectic as the results, but certain preoccupations can be detected: an interest in the human figure and a desire to master its representation in its classic form, the nude; a feeling for landscape and essays in the conventions of landscape painting in the past, for instance those of Poussin; a sensuality that attracted

* A brilliant study of these developments is Francis Haskell's *Rediscoveries in Art* (1976). One of the leading figures in rediscovering lost artists was Théophile Thoré, an early admirer and subsequent friend of Millet.

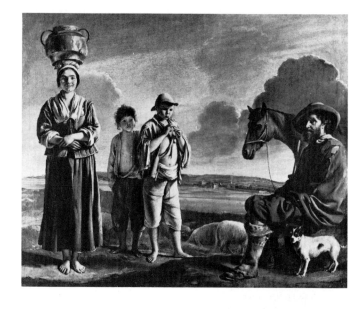

fig. 4 Louis LE NAIN
Landscape with Figures
Oil on canvas 54·6×67·3 cm. London,
Victoria and Albert Museum

Paintings by the neglected seventeenth-
century brothers Le Nain from Laon of rustic
scenes were rediscovered in the 1840s and
made their appearance on the walls of the
Louvre in 1848 through the exertions of
Champfleury, a friend of Courbet, theorist of
Realism and writer on French popular arts.
The 'naïve' quality of these works, with their
static poses, 'awkward' compositions and
peasant subjects were admired and may well
have exercised some influence on many
nineteenth-century artists, notably Courbet
himself.

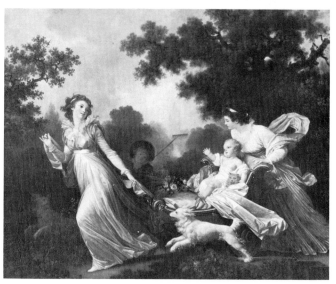

fig. 5 Jean-Honoré FRAGONARD and
Marguerite GÉRARD
The Cherished Child
Oil on canvas 43·8×54·4 cm. Cambridge
(Massachusetts), Fogg Art Museum (gift of
Charles E. Dunlap)

This composition has been suggested as a
source for Millet's *Return from the Fields* (Plate
6). It typifies the eighteenth-century approach
to rustic genre which was essentially
picturesque, pastoral and prettified, providing
an excuse for flowing drapery, rhythmic line
and delicate colour.

him to eighteenth-century French art on the lighter side
and to Spanish art in its darker moments; and a moral
sense of man's destiny and search for forms appro-
priate to its expression. This drew him to both Michel-
angelo and the Italian Primitives. Of a figure by Michel-
angelo he observed 'that the man who had done that
was able, with a single figure, to personify the good
and the evil of humanity', while of the Primitives, he
said that

After Michelangelo and Poussin, I returned to my first inclination
for the primitive masters, to those subjects as simple as childhood,
to those unconscious expressions, to those beings who say nothing
but feel full of life, or who suffer patiently without protest, with-
out complaint and who submit to the law of mankind and do not
even question why. Unlike today, they did not make an art of
revolution.

During this early period of forays into the art of the
past, Millet was trying to acquire the language of
forms and colour in order to give expression to his
fatalistic idea of man and his specific sense of place. By
1850, however, his borrowings became less obvious, his

distinctive style emerging with *The Sower* (Plate 20),
which he exhibited at the Salon in 1850–51 together
with *The Harvesters* (Paris, Musée du Louvre, 1850). At
that same Salon, Gustave Courbet exhibited *The Stone-
breakers* (destroyed, 1849–50) (fig. 6), *The Burial at
Ornans* (Paris, Musée du Louvre, 1850) and *The Peasants
of Flagey Returning from the Fair* (now lost, 1850; later
version, Besançon, Musée des Beaux-Arts, c. 1855).
These large-scale figure paintings of peasant and rural
subjects inspired a critic, Prosper Haussard, to exclaim,
'We are ready to applaud the formation of a new school
of which M. Courbet and M. Millet may be the chiefs'
(*Le Pays*, 22 April 1851). This new school has been
called Realism and has been characterized by its interest
in and novel treatment of the working class, peasants
and labourers, in van Gogh's phrase, by elevating sub-
jects that had traditionally been confined to genre to the
scale and seriousness reserved for subjects from the
chronicles of the great in history, mythology and
religion. The move from the past to the contemporary
also included a move from the religious to the secular.

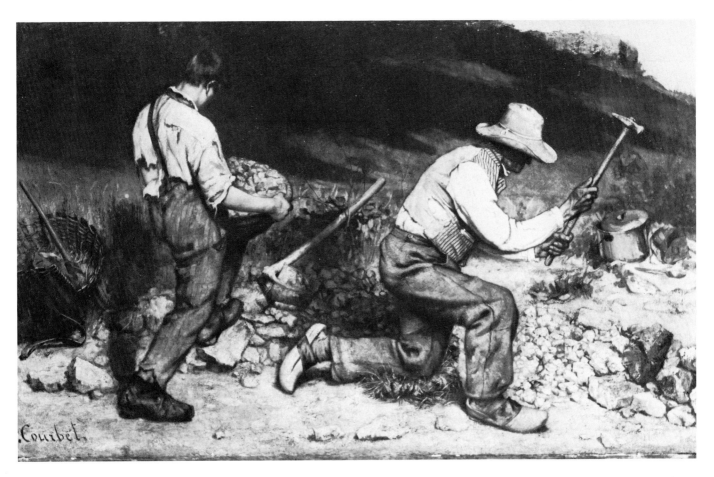

fig. 6 Gustave COURBET
The Stonebreakers
Oil on canvas 165 × 238 cm. 1849. formerly
Dresden, Staatliche Gemäldegalerie, but
destroyed in World War II

On many levels Courbet provides an
illuminating comparison with Millet. Both
were of peasant origin, but both were from the
upper reaches of that class. Both spent the
1840s in experimentation and found their
distinctive style in the period following the
1848 revolution by turning to peasant subjects
and a technique that outraged centre and
right-wing critics, but the similarity ends there
for Courbet was far more involved in the
politics of Paris, 'Bohemia' and the left and the
significance of his works, which despite his
rural subjects remained governed by the
metropolis, lies in a different sphere from that
of Millet's evocation of peasant consciousness.
The particular preoccupations of the two
artists took them in different directions, and
while it is not unimportant to note the
conjunction of interests and style in the
famous Salon of 1850–51, any attempt to link
the two under the banner of Realism can
only be a superficial exercise in art historical
categorization.

Why did Millet participate?

According to Sensier, there was a decisive break in
Millet's work for moral reasons. He records an incident
in which Millet overheard two men in front of a
dealer's window looking at some delightful nude of his
and remarking that its painter was a specialist in
buttocks and breasts, at which the pious artist resolved

never again to paint such degenerate trash! Sensier's
account is incorrect on two scores as Millet had painted
rural scenes before this episode (Plates 8–12) and con-
tinued to paint nymphs and bathers after 1850, for
instance the *Nymph Dragged along by Cupids* of 1851 in the
collection of Lord Clark.

A second explanation lies in the events of 1848 when
many artists participated in the two revolutions that
successively shook Paris. Baudelaire took to the streets
with a gun, Courbet produced a woodcut for Baudel-
aire's radical magazine, *Le Salut Public* (fig. 7), and
Millet, at the time reduced to painting signs to make
some money, carried a gun in the June riots, but on
which side is unknown. His painting in the Salon that
year, *The Winnower* (U.S.A., private collection), was
well received and was purchased by an official of the
new republic, Ledru Rollin, who gave Millet his first
taste of the coveted resources of state patronage by
commissioning a large-scale work from him. The colours
of *The Winnower*, red, blue and white, are the colours of
the tricolour, the revolutionary flag. What Millet in-
tended by it, as opposed to what critics and admirers of
the work saw it symbolize, remains unclear. The single,
labouring figure of *The Winnower* easily takes its place
within the context of Millet's work of the 1840s (Plates
8–10), but its monumental scale and elimination of
picturesque detail prefigure the 'epic naturalism' of the
peasant paintings of the 1850s. 1848 was a catalyst for
many artists, a moment which was a dramatic con-
juncture of historical events, cultural change and

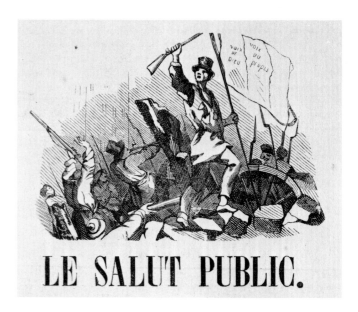

fig. 7 Gustave COURBET
Le Salut Public
Engraving after a drawing for the frontispiece
of the magazine *Le Salut Public*, no. 2 (1848).
Paris, Bibliothèque Nationale

A short-lived publication, *Le Salut Public*
represented the engagement of many artists
and writers with the popular elements of the
1848 revolution. Courbet quoted Delacroix's
famous painting of the 1830 revolution,
Liberty on the Barricades (Paris, Musée du
Louvre), while producing a strange concoction
for his main figure, part bourgeois, part
worker, which may reflect the radical
bourgeois' confused position in the events of
February to June 1848 and throw some light
on Millet's equally ambiguous attitude.

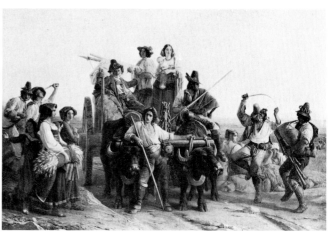

fig. 8 Léopold ROBERT
Arrival of the Harvesters
Oil on canvas 140 × 198 cm. 1830. Paris,
Musée du Louvre

The picturesque and folklorique predominate
in Robert's costume piece of happy Italian
peasants seen here in a posed tableau. One
can understand the shock Millet's rough
surfaces, solemn colour and work-worn faces
must have been to a public accustomed to the
fine painting, lively colour and rural
merriments of the Romantic genre of artists
like Robert.

personal crisis from which Millet emerged, no longer a
bastard eclecticist of uneasy style.

He physically removed himself from a cholera-
stricken Paris in 1849 and went to Barbizon; his works
were never again so much part of so particular a histori-
cal event, and he engaged thereafter in a dialogue in
form with his experiences of man and nature, moving
from large figures in stunted landscapes to smaller
figures and ever more panoramic and embracing space,
to work at the presentation of toil, to portray its en-
vironment.

In 1848 at least 75% of the population of France was
still engaged on the land. The peasant class was the
single largest class and justified the term, the people.
However, against the obvious revolutionary potential
of the masses at a time of upheaval, one has to set
another, more conservative and equally often ex-
pressed view of the character of the people of France.
In the 1840s writers like George Sand turned to the
countryside for inspiration in a series of rustic novels.
In *La mare au diable* (1846), the best known, the
dominant mood of contemplative melancholy is set by
a description of a Holbein woodcut from the series *The
Dance of Death*, which shows a ploughman called away

by Death, who takes hold of his oxen. It is accompanied
by the quatrain:

> With the sweat of your brow
> Shall you earn your bread
> After long travail and labour
> Here is death to escort you away.

Millet owned that woodcut, and read Sand's novel,
but disliked her poetic idealization of the peasants
which ignored their reality. In 1846, the great French
historian Jules Michelet published a study of the people
of France, *Le Peuple*. Berating the false picture the
Romantics had given of the peasant (fig. 8) he ex-
claimed that 'If they [the Romantics] themselves had
descended through personal sufferings into the pro-
found realities of the life of their times, they would
have realized that the family, labour, the most humble
life of the people has its own holiness and poetry.'
Michelet thus cast a semi-religious light over the real
processes of peasant life which would perhaps have
accorded with Millet's own biblical tendencies. Further
on, Michelet turned to another metaphor in explaining
the peasant's feeling for his land: on Sundays, when the
women are at church, the peasant man is with his
mistress—the land, which he loves with a passion,

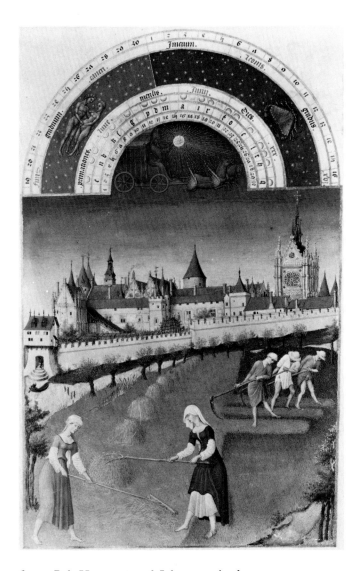

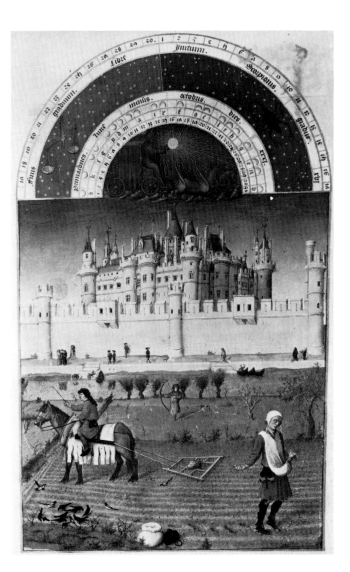

fig. 9 Pol, Hermant and Jehannequin de LIMBOURG
June from *Les très riches heures du duc de Berry*
Chantilly, Musée Condé

This early fifteenth-century scene of harvesting is a typical representation of the month of June and shows reapers in the background and women with rakes and forks in the foreground. Both motifs occurred separately in Millet's works such as *The Reaper* (Plate 44) and in the background of *The Gleaners*. The manuscript containing these exquisite illustrations to the seasonal occupations of both peasants and aristocrats was rediscovered in 1855 by the exiled duc d'Aumale, who purchased it in Italy and eventually brought it back to France.

fig. 10 Pol, Hermant and Jehannequin de LIMBOURG
October from *Les très riches heures du duc de Berry*
Chantilly, Musée Condé

Millet's most famous image, *The Sower*, can also be connected to the late medieval Books of Hours. The delicacy and linear treatment of the manuscript illuminator is stylistically distinct from Millet's monumental oils, but the feel and composition come surprisingly close to Millet's drawing (Plate 21) of 1850–51, now in the Ashmolean Museum, Oxford. It is not clear whether this manuscript was known at the period beyond a small circle of collectors, but it is illustrated here as one of the finest examples of the medieval tradition of religious books using seasonal labours and rural types.

ploughs, inseminates and helps to bring forth new life. The Frenchman marries the land of France. Such sexual imagery, brought to its poetic fullness in Emile Zola's novel, *Earth* (1888), was noticed by Dali in the work of Millet. Addressing himself to the artists of France, enjoining them to portray the people, Michelet repeated the image.

Most who portray the people are not of the people. He who wants to do so must *penetrate* the earth and its instincts. [author's italics]

If we turn now to Millet's paintings and drawings we can find elements of all these threads, contemporary and personal, political and biblical and ultimately sexual, forged into an impressive body of work.

The Sower occurred first in Millet's work in a small painting of 1846–47 (Plate 18), but exploded in the Boston version of 1850 (Plates II and 19), the figure literally bulging from the canvas in virtual relief. The highlights on his fist bring forward visually the crucial

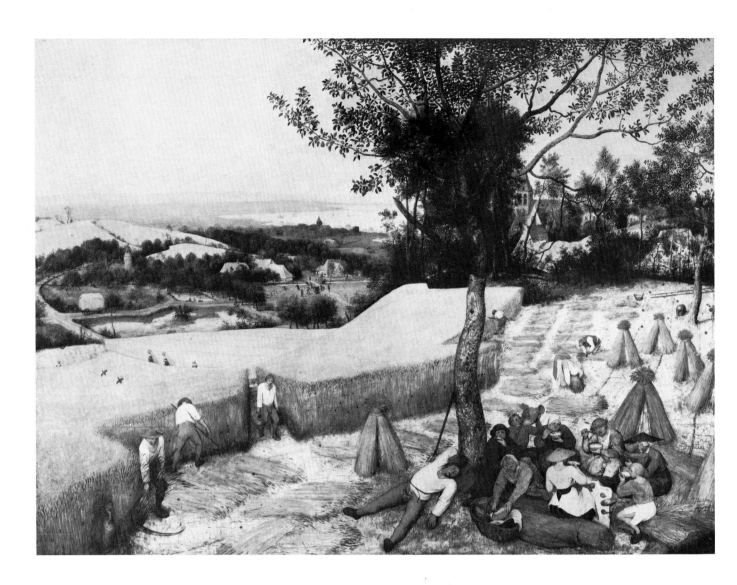

fig. 11 Pieter BRUEGEL the elder
The Harvesters
Oil on wood 117 × 158 cm. 1565. New York,
Metropolitan Museum of Art (Rogers fund)

Millet collected works, particularly prints by
Bruegel, and while it is difficult to establish
whether he knew this painting, the parallels
between Bruegel's scene of summer
activities and motifs in Millet's own work are
remarkable. The harvesters resting in the
foreground invite comparison with Millet's
Harvesters Resting (Plate 23), the man reaping
on the left with the same subject in Plate 44,
while the bending woman in the back suggests
a source for the main motif in *The Gleaners*.

gesture and, through the thickness of the impasto,
project it off the surface of the canvas into our space.
For reasons that are still unclear Millet painted another
version (Plate 20) for the Salon of 1850–51, which has
been considerably reworked and possibly relined in
restoration. These processes diminish its force consider-
ably in comparison with its predecessor. The sower,
himself, however, is more fully integrated into his
environment in the composition and, by virtue of the
way the paint of the sky and earth has been brushed
over the contours of the figure, locking it into the canvas

surface, is in striking contrast to the relief of the earlier
image.

The painting invited two very different interpreta-
tions. In *La Démocratie Pacifique*, Sabathier-Ungher, a
Fourierist critic wrote:

Come, poor labourer, sow your seed, throw out to the soil your
fistfuls of grain! The soil is fertile and will bear fruit, but next year
as this, you will be poor and you will work by the sweat of your
brow, because men have so arranged it that work is a curse.... His
gesture has a Michelangelesque energy ... he is a Florentine con-
struction. He is the modern Demos.

A more moderate critic, Théophile Gautier, began his
review reassuringly, 'The Sower of M. Millet impresses
me like the first pages of *La mare au diable* by George
Sand'; and four years later, while reviewing Millet's
The Peasant Grafting a Tree, now in a private collection
in the United States of America (Salon, 1855; Plate 30
is a study for this painting), he enlarged on the sacred
mission of the sower.

His 'Sower' exhibited some years ago had a rare grandeur and
elevation ... but the gesture with which the workman threw the
sacred wheat into the furrow was so beautiful that Triptolemus
guided by Ceres, on some Greek bas-relief, could not have had
more majesty.... 'The Peasant Grafting a Tree' is ... of extreme
simplicity. The man seems to accomplish some mystic ceremony,
to be the obscure priest of a divine rural cult.

It was the heroic scale and sense of divine mission coupled with the brutal paint and ugly figures that angered and baffled the critics and with the next major exhibited oil, *The Gleaners* (Plate 25), certain critics exploded. Gleaning was a task reserved for the poorest and most destitute, and around Barbizon, paupers were licensed to glean by the commune. Like Courbet's *Stonebreakers* (fig. 6) gleaners were the poorest of the poor. Yet Millet approached the subject with the seriousness of a classical painter, making innumerable studies of the composition and figures (see Herbert, 'Dossier on the Gleaners' in the French catalogue of the 1976 exhibition). In an earlier version (Plate 26), in the British Museum, the figures dominate in superbly conceived formal arrangement against the vague backdrop of large stacks. In the painting, however, the stacks are pushed back and the landscape opened out to show the relation of the gleaners to the harvesters, an echo of the 1853 *Harvesters Resting* (Plate 23). Pride of place is still given to the three women, whose weighty and laborious gestures contrast sharply to the energetic bustle of group activities in the distance. This meaningful juxtaposition was not lost on Paul de St. Victor:

His three Gleaners have gigantic pretensions, they pose as the Three Fates of Poverty . . . their ugliness and their grossness unrelieved. These paupers do not move me, they have too much pride; they visibly betray their pretensions to descent from Michelangelo's Sibyls and their ambition to wear their rags with more pride than the harvesters of Poussin their draperies.

Poussinesque the theme, Michelangelesque the figures, the subject also belongs to the northern tradition of the illustrations of the seasons in devotional Books of Hours like *Les très riches heures du duc de Berry* (figs. 9 and 10) and such paintings by Bruegel, an artist known to Millet, as *The Harvesters* in the Metropolitan Museum of Art in New York (fig. 11). Indeed, the subject of Millet's *Gleaners* originated in a magazine illustration for the month of August and was developed in a drawing of 1852 entitled *Summer* (U.S.A., private collection) for a series of paintings of *The Four Seasons*.

However, Millet's painting is nonetheless disquieting. Colouristically and compositionally, the centre point of *The Gleaners* is a large touch of red on the bonnet of a distant harvester, a colour that may have inspired Jean Rousseau's comment that the harvesters reminded him of the 'scaffolds and pikes of 1793'. Furthermore there is an intriguing recurrence of the mystical number three in the three gleaners, the three women with sheaves on their shoulders in the middle ground and the distant threesome of stacks repeated in the nearer group on the left.

The seasons and the rhythms of labour were joined by an interest in times of the day in *The Angelus* of 1855–57 (Plate III), in which a man and a woman stand bowed in prayer in a gloriously painted sunset. It is a smaller painting than *The Gleaners*, richly worked to give to the earth a real substance, to the figures

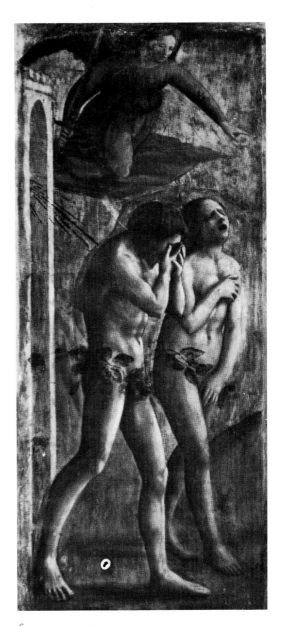

fig. 12 MASACCIO
Expulsion of Adam and Eve from the Garden of Eden
Fresco. 1428. Florence, Brancacci Chapel of the Carmelite Church

Masaccio's style was monumental, moral and powerfully realistic. The scale of his figures and their expressive silhouettes anticipated Millet's idiom, and the suggested comparison with *Going to Work* (Plate 22), while visually striking, emphasizes the underlying religious iconography in Millet's peasant painting.

bodily weight and to the tools they have just set aside a pictorial prominence. The central pair have the statuesque quality of an ancient Adam and Eve, an image specifically referred to in the earlier couple in *Going to Work* (Plate 22) of 1851–53, which critics have compared to Masaccio's *Expulsion of Adam and Eve from the Garden of Eden* in the Brancacci Chapel in Florence (fig. 12). However, in *The Angelus*, as in *The Gleaners*, the landscape was given greater importance, and the environment extends beyond the figures into an open plain, while the very colour which evokes the setting

sun envelops the pair in a red-hued embrace. In a letter of 1865 Millet recalled his purpose: 'The Angelus is a painting which I did while thinking how, while at work in the fields, my grandmother never failed to respond to the sound of the bells, to stop us at our work to make us say the prayer of the Angelus for *the poor dead*, piously, hat in hand.'

A personal reminiscence of a funerary theme, reflected in the symbolic twilight of a dying day, takes on a larger meaning through the almost archetypal representation of the figure of Woman, hands clasped over her breast to reveal her belly onto which light falls, emphasizing the source of regeneration, while at her feet another symbol, the open vessel of her basket, contains the fruit of the earth's fertility. The more shadowy and less solidly drawn figure of Man stands beside his upright fork, whose prongs are lodged in the earth. This can be compared with the many-levelled imagery in both *The Peasant Grafting a Tree*, in which a woman and child watch the man's ceremonial act of grafting new stock on an old tree, and *The Peasant Family* (Plate 35), in which a child is placed symbolically between the male and female figures.*

In 1863 Millet once again ran the gauntlet of critical hostility in order to 'somewhat disturb the fortunate in their rest' (letter to Sensier, 1863) by exhibiting the *Man with the Hoe* (Plate 29). The absolute unity of man and work, man and instrument, is established by the compositional pyramid created by the figure who leans heavily on his hoe, looking up, mindlessly numbed by work, to stretch his back and take a breather. But the unrelieved toil-weariness of the face, the expressionless eyes, open mouth, coarse garments and graceless stance, terrorized the more 'fortunate' and one critic dubbed this peasant 'Dumoulard', a notorious convict who had murdered his employers.

But in the middle distance a charming still-life beckons to us, serving as a device to join the foreground and the background but given disturbing prominence nonetheless. In his book, *Les paysans du XIXème siècle* (1856), Eugène Bonnemère provides a clue. After the French Revolution many, but by no means all, peasants won ownership of their land, which was proudly passed on from father to children in ever diminishing plots. Thus in an apparently vast open field there often existed minute subdivisions of landholdings demarcated by nothing more than a single stone at which point a peasant might leave his discarded clothes while at work there. Bonnemère wrote:

Respect it! That stone. Look at it beside this solitary man, isolated, bent and crushed downwards towards the earth, who, as you pass

* These images can be compared to ancient fertility myths: see R. Graves, *The White Goddess* (1961). Salvador Dali, in *Le mythe tragique de L'Angélus de Millet* (1963), emphasizes the fact that a coffin shape was discovered at the feet of the woman when the painting was X-rayed in the 1960s. He links this to the symbolism of the earth mother, the yearly male consort and, finally, to oedipal myths, illustrating the sexual symbolism of the fork, the basket and especially the wheelbarrow in folk art.

by, halts a moment in his deforming labour, and resting on his spade, the spade of Cain, watches you with a defiant air, full of hatred.

Millet's work may be a record of the rules and conventions of that class. Edward Wheelwright, an American art student who went to Barbizon as Millet's pupil in the 1850s, catalogued many of the habits of the Barbizon people which give new and specific meaning to many of Millet's works. For instance in *The Diggers* (Plate 46), a work similar to the *Man with the Hoe*, two men dig with 'the spade of Cain', an activity which Wheelwright helps us to understand. Small proprietors, too poor to afford a plough and team, or with plots too tiny to take one, dug over their stony ground by hand with just such a tool. 'None of the tasks which fall to the lot of the French peasant has a more pathetic significance than that of the Bêcheur; none speak more plainly of the poverty, the hardship and helplessness of his lot.'

Throughout the 1850s and 1860s Millet chronicled the life around him in Barbizon in serial variations on the theme of labour, for instance, the twelve labours of the fields (Plate 44) and the four times of the day (Plates 40–43).

In these series one can see the significant development of landscape gradually assuming increasing importance, the figure becoming more integrated into its environment. Millet explained this process in a letter to Sensier:

I admit only with difficulty that one can separate the peasant from Nature. He is in some way an integral part of it, like a tree, or ox.... From the artistic point of view he finds himself simply the most elevated point in a system that begins with the vegetable and ends with him.

In order to convey that sense of man as a higher animal inextricably bound to nature, Millet turned to pastel as his chief medium and to the series as his format and created through an almost synaesthetic effect of sight and sound a pictorial expression of that interdependence. Such a relationship of man and nature could be interpreted as the ultimate in bourgeois conservatism (see Barthes, p. 142), but I think that Millet was attempting something that John Berger believed to be impossible within the tradition of landscape up to the mid-nineteenth century. Berger explains that scenic landscape in European art is essentially a visitor's *view* of it, not an experience of *being in* it or working *on* it. I think one can see Millet trying to overcome this in the increasingly pure landscape works of the 1860s and 1870s by pictorial and technical means; he achieved it most successfully in pastel. A superb example is the large pastel *Winter with Crows* (Plate V) of 1862. The colours are chilling, the desolate emptiness is rendered more poignant by the abandoned tools which are eloquent of the absence of man. But the most remarkable effect is that of distance, of extensive space which breaks the confines of the frame as the dynamism of

the pastel lines with their insistent directional pattern draws us into the great plain of Chailly and through the almost tangible space of the sky. Wheelwright reports a lesson he once received from Millet:

Every landscape, however small, should contain the possibility of being indefinitely extended on either side; every glimpse of the horizon should be felt to be a segment of the great circle that bounds our vision. The observation of this rule helps wonderfully to give a picture of that true out of doors look.

Another device Millet used was an all-over tonality or colour key, created by coloured grounds so that the figures seemed veiled by space, emerging only as expressive silhouettes. As daylight fades or in the gentler light of the moon, one can observe in nature the unifying effects of half-tones, which Millet superbly captured in such works as *The Sheepfold* (Plate 48) and the oil painting *Starry Night* (Plate IV).

Thus one is inevitably drawn to another important element of Millet's work, his *matière*, through which he, the painter, searched for a formal language of pictorial equivalents for the hitherto unexpressed experiences of the peasant. It was often said in nineteenth-century writings on the peasants that they had no feeling for landscape. This may be true of landscape when treated as a scenic view, but in Millet's paintings, drawings and pastels, in their physical and evocative powers, one can feel the land, the sky, the substance, the weather and the seasons.

In a letter of 23 April 1867 Millet explained that 'As far as giving explanations of my painting procedures are concerned, there's a lot that could be said, but I am not really involved in them much, and if there are procedures they are not important to me except as a way of *entering* so to say into my subject, the difficulties of life etc' [author's italics].

This, like many of Millet's disclaimers, is rather puzzling at first sight, more especially when taken in the context of Millet's extensive study of the procedures and conventions of representation of the art of the past, which included classical landscape, eighteenth-century pastorals, Gothic stained glass and manuscripts, Japanese prints, the school of Fontainebleau, Spanish and Dutch seventeenth-century art, Bruegel, Renaissance woodcuts, Pompeian wall paintings and the work of contemporaries like Delacroix and Diaz. He built up a considerable collection of examples of many of these and even admired photographs by Cuvelier; photographs, in common with Japanese prints, offered new ways of representing space or perspective. Further, the evidence of his numerous sketches and compositional studies for major works such as *The Gleaners* or *Death and the Woodcutter* (Plates 27 and 28) of 1859 show him to have been concerned with the process of composition. It is clear that Millet rarely worked directly from nature, preferring rather to take a quick mnemonic sketch and develop it in the studio, as was the case with *Autumn* (Plate 70) for which a minute drawing of the three scarcely delineated stacks exists in a pocket sketchbook.

This evidence does not mean that Millet should be seen as a classical or formalist artist, for it conforms to the pattern of those nineteenth-century painters who engaged in an extensive dialogue with the art of the past in order to break out of their conventions and formulae. This return to the past to find the new can be seen in the work of the English Pre-Raphaelites, whose brilliant colours may have influenced Millet's jewel-like intensity in a late painting like *Spring* (Plate 68). In France, artists like Manet and Cézanne tried to break out of traditional one-point perspective in order to create new conventions for representing space. A fuller discussion of this is included in P. Francastel's *Peinture et société: Naissance et destruction d'un espace plastique. De la Renaissance au Cubisme* (1965). The letter quoted above, in conjunction with other statements by the artist, present procedure as a means to enter into his subject (a phrase that echoes Michelet, p. 15). But what did it mean for Millet?

The paintings of the 1840s reveal to us an artist who sensuously enjoyed thick paint, rich colour and the working of his *matière* (Plate 3), which was at times positively ferocious, dense and passionate.

Théophile Gautier wrote of *Oedipus Taken Down from the Tree* (Plate 5), Millet's Salon work of 1847, that 'This is touched with an unbelievable fury and audacity, worked over with an impasto thick like mortar, on a canvas worn bare and thickly grained, with brushes bigger than a fist and covered in fearful shadows.' Gautier was inspired when he described the physical qualities of *The Winnower* (U.S.A., private collection), displayed at the Salon of 1848: 'He trowels onto his dishcloth canvas, using no turps and no oil, great masonries of colour, paint so dry that no varnish can quench its thirst. Nothing could be more rugged, ferocious, bristling or crude.'

The analogies are instructive: artist as workman, building a canvas, brushes like trowels, paint as mortar, effects rugged like stone or parched like earth. These qualities of the paint evoke what Gaston Bachelard, in his study of the symbolism of the earth in literature, considered to be the essential qualities of the earth for those who for centuries have worked it, 'la matière forgée', the hardness, softness, resistance of worked matter. Millet passed his youth on the land and the memory of it is implicit in the very manner of his application of paint. Gautier, once again, brilliantly perceived that fact when he wrote of *The Sower* that it seemed 'painted with the very earth he is sowing'.

The unquenchable thirst of Millet's pigment was used to convey that very quality of the earth in *Hagar and Ishmael in the Desert* (Plate 15), the work commissioned in 1848, completed in 1849, but never submitted. It is perhaps a surprisingly classical subject for the painter of the successful *Winnower*, two nudes set in a bare land-

scape, but it is a desert whose unrelieved barrenness is expressed not by classical perspective and vistas of extensive space, not by any details, but by an unprecedentedly empty canvas and an intensely physical expanse of paint. Rarely has the resistant, unyielding hostility of the infertile earth been so tragically expressed in the history of European art.

In the figure paintings of the 1850s much of this power seems to have gone underground. Perhaps Millet wanted to avoid being categorized as ferocious, crude, rugged and brutal, as his peasants so frequently were, and perhaps this explains the second and more contained version of *The Sower* (Plate 20). His paint surfaces subsided, figures no longer bulged so ominously off the canvas but were locked into it behind the mirror of surface varnish. So dead does the paint seem in such works as *The Peasant Grafting a Tree* of 1855 (U.S.A., private collection) and *The Woman Grazing her Cow* of 1858 (Bourg-en-Bresse, Musée de l'Ain), that it is hard to like Millet. But significantly as the landscape opened out behind his figures and the amount of earth painted increased, paint itself took on life again. In the Salon work of 1865, *The Shepherdess Guarding her Flock* (Plate 58), dabs of paint and brushstrokes give life to the growing vegetation in the foreground, while thin parallel streaks of a very liquid colour, occupying a tiny slice of the overall canvas, create a dazzling rush into space. The Symbolist author Joris-Karl Huysmans, in a review of the 1887 retrospective of Millet (reprinted in *Certains*, 1904, p. 194), grasped this quality:

Brute matter, the earth dense and impenetrable, yet alive and rich; one senses its substance and heaviness; one feels that beneath its mounds and weeds, it is thrusting forth its fullness; one breathes in its odour, one can sift it through one's fingers, and dig one's toes into it. For the majority of landscapists the earth is superficial; for Millet it has depth, weight and profound meaning.

Rather than relying upon direct studies from nature for each individual picture, a habit Millet discouraged in his pupils, he worked instead on many paintings at the same time in his studio, but nevertheless, at any one point in the progress of these many works, each had, according to his visitors, an overall unity at that stage in its development. Building up a painting layer by layer was typical of Delacroix, an artist who exercised considerable influence on Millet; Millet later bought a number of sketches from the sale of Delacroix's studio in 1864. The aesthetic implications of this procedure are deeply Romantic. Charles Baudelaire, Delacroix's main apologist, described this artistic process as analogous to the cycle of the Creation: first chaos, then the division of light and shade, the particularization of vegetable, animal and human elements and finally an entire world. To the artist, therefore, was ascribed a semi-divine rôle as 'demi-urgos', repeating the original Creation of the world with every creation of his own of a painted world on canvas, through the hallowed conventions of art, chiaroscuro, colour and anatomy.

In an unfinished oil sketch in the Louvre, *The Shepherdess with a Flock* (Plate 52), the precise configurations of the girl and the sheep appear to be emerging through the veil of paint on a canvas on which the lights and shades have been blocked in. In certain unfinished works, one can see the toned grounds, learnt from seventeenth-century Dutch artists, which Millet used either to maintain an overall tonality, as for instance, in the Philadelphia *Porte aux Vaches in the Snow* (Plate 51) of 1853, or to create coloured light permeating and transforming all parts of the landscape, as in *Autumn* (Plate 70) of 1868–73 with its bright pink ground conveying the atmosphere of a September afternoon.

Millet used toned grounds in pastels as well; in *The Diggers* (Plate 46) a dull orange buff provides a warm tone against which the white smoke and the deep-green grass take on an increased luminosity. The absence of light and the enveloping darkness of twilight are conveyed equally substantially by the reverse process of a light ground worked over by dense lines of pastel or black crayon as in *Twilight* of 1858–59 (Boston, Museum of Fine Arts), in which the figures dissolve in the encroaching darkness. In *After a Day's Work* of 1867–69 (University of Rochester, Memorial Art Gallery), the use of a buff ground enables one to feel the daylight fading. The all-over tone of a ground and the web of pastel strokes give real substance to air and space so marvellously that one wonders at Millet's humility when he exclaimed, 'O aerial spaces which made me dream when I was a child, will I never be allowed even to suggest you?' (letter to Sensier, 3 January 1866).

The material presence of coloured grounds makes the effects of light almost tangible and the reflected coloured light and sombre density of its absence strike the spectator's eye with palpable force. Thus not only is the earth portrayed by Millet but also the envelope of light and atmosphere which indicates weather, season and time of day, the important aspects of nature by which the man of the land lives and works.

At the beginning of this book some of the polarities observed in Millet's work are listed. Kenneth Clark, addressing himself to the Romantic vs. Classical debate (Clark, 1973), draws attention to the sexual element in Millet's sensuous use of paint. Contrasting the erotic works of his youth (Plates 1 and 7) with the drabness of some of his peasant paintings of the 1850s, he explains the loss of force by the 'suppression of the old Adam', and, while praising the success of others, he claims that 'As with Poussin, he [Millet] could hardly have escaped the endemic disease of ideal art—insipid emptiness— unless he had started with a double dose of sensuality.' But the sexual paradigm in Millet's work must be seen in a much broader framework, the complex interaction of Millet's personal experience with the idea of the virile artist as demi-urge in a material and with subjects that echo age-old fertility myths of the Earth, to

which Michelet, Bachelard and Dali draw our attention. As Lucien Lepoittevin (Lepoittevin, 1973) commented when establishing a link between agriculture and painting in Millet's portrayals of the peasant man and woman and their work, 'The struggle of man with the material element is symbolically sexual as is the august gesture of the Sower.'

One is thus brought back, yet again, to the seminal image of Millet's *oeuvre*, *The Sower*, a biographical, formal and ultimately mythic statement in oil on canvas to which we must look to understand how the profound and varied sources of Millet's art are synthesized and its apparent contradictions resolved.

Chronology

1814 Jean-François Millet was born at Gruchy, a small village east of Cherbourg on 4 October.

1833 Millet began part-time training with the portrait painter Mouchel (1807–1846) in Cherbourg, but he returned frequently to work on the family farm.

1835 After the death of his father, Millet almost forsook his art studies, but eventually returned to Cherbourg to study with Langlois (1803–1846). The collection of Thomas Henry of Old Masters of the Spanish, French and Netherlandish schools was made public. Millet studied there, copying the paintings of Jordaens, van Loo and Rogier van der Weyden.

1837 In January Millet went to Paris on a scholarship from the municipality of Cherbourg. He entered the studio of Paul Delaroche (1797–1856) at the Ecole des Beaux-Arts.

1839 In April Millet competed unsuccessfully for the painting prize in the Prix de Rome and left the Ecole shortly after. Cherbourg terminated the scholarship at the end of this year. His Salon submission, *Saint Anne Instructing the Virgin* was rejected by the jury. Sensier listed two other religious subjects for this year, *Ruth and Boaz* and *Jacob and Laban*.

1840 Millet sent two portraits to the Salon, one, a *Portrait of M.L.F.* [Lefranc] (Zürich, Nathan collection) was accepted. On his return to Normandy, he painted portraits of his family.

1841 Millet wintered in Cherbourg where the city commissioned him to paint a posthumous portrait of a former mayor, Colonel Javain, but the finished work was not accepted. He visited Paris and returned to Cherbourg in November to marry Pauline-Virginie Ono, whom he took back to Paris.

1843 Two works for the Salon, *Maria Robusti* (now lost) and a pastel portrait of his friend Marolle, were rejected.

1844 Millet's wife died in April, and he returned to Cherbourg. Two works with pastoral themes, *The Milkmaid* and *The Riding Lesson*, were accepted at the Salon and were favourably noticed by the artist Narcisse Diaz and the critic Théophile Thoré.

1845 Millet moved to Le Havre, painted portraits and light-hearted mythological scenes. He began to live with Catherine Lemaire, a servant he had met in Cherbourg. He left for Paris on the proceeds of a successful sale of his works.

1846 Through artists such as Troyon, whom he had met, Millet was introduced to Paris dealers, Durand Ruel, Schroth and Deforge, for whom he produced pastels and nudes. *The Temptation of St. Jerome* (canvas cut up and reused) was rejected by the Salon jury.

1847 Sensier and Millet met and became friends on the basis of a shared country background. Millet became part of a circle of artists who later had connections with Barbizon. *Oedipus Taken Down from the Tree* (Plate 5) won him his first substantial critical success.

1848 In February the revolution broke out in Paris, Louis Philippe was deposed and a provisional republican government set up. Millet's attitudes are unknown but many of his friends were republicans. In the free Salon Millet showed *The Winnower*, which was bought by a member of the government, Ledru Rollin, who won for him a commission worth 1800 francs. However, Millet also exhibited a religious painting, *The Captivity of the Jews*, which did not find favour. In the days of late June, a second, popular uprising in support of the radical provisional government, which had been defeated in the elections, was crushed by General Cavaignac. In December Louis Napoleon Bonaparte was elected president.

1849 Millet abandoned *Hagar and Ishmael* and substituted *The Harvesters* (Paris, Musée du Louvre) to fulfil the state commission. He was represented at the Salon by a small unidentified painting of a *Seated Shepherdess*. In June he and his family left the unrest and threat of cholera in Paris and went to Barbizon where he then settled for the rest of his life.

1850 Millet was successful at the Salon with *The Sower* (Plate 20) and *Trussing Hay* (Paris, Musée du Louvre). Sensier became Millet's agent, providing materials in exchange for pictures and selling them to small dealers.

1851 In May Millet's grandmother died, but he did not attend the funeral. While working in Narcisse Diaz's studio, he was introduced to the left-wing philosopher Proudhon. In December Louis Napoleon staged his *coup d'état* and defeated the republican resistance.

1852 Jean-Baptiste Millet, the artist's brother, arrived in Barbizon to study art with his brother. In December Louis Napoleon became emperor.

1853 Engravings after Millet's woodblocks were published in *L'Illustration*, and in 1855 they were issued as the album of *The Labours of the Fields*. Through visiting American art students and collectors Millet established connections with the American market. His prices were rising to about 200 francs for a small picture. At the Salon, where he exhibited *Harvesters Resting* (Plate 23), *A Sheepshearer* and *Shepherd: Evening*, Millet received a second-class medal. After the death of his mother in April, Millet returned to Gruchy for the first time since 1844. In September the civil marriage of Millet and Catherine Lemaire took place.

1854 With the fruits of his modest earnings and a small inheritance, Millet was able to spend four months in Normandy, making sketches of his home and native countryside to be worked up into paintings in Barbizon.

1855 At the Exposition Internationale in Paris only one of three works submitted by Millet was accepted. *The Peasant Grafting a Tree* was highly praised by the critic Gautier and was purchased for 4000 francs, supposedly by an anonymous American, who was in fact Théodore Rousseau, wishing to help his friend.

1856 This was a year of great depression and financial anxiety, which was aggravated by the desperately low prices of his works at the Campredon sale in December.

1857 *The Gleaners* (Plate 25) was strongly attacked in the Salon by conservatives but won for Millet the support of the liberal Castagnary.

1859 The Salon jury accepted *Women Pasturing her Cow* (Bourg-en-Bresse, Musée de l'Ain) but rejected *Death and the Woodcutter* (Plate 27). The latter was exhibited privately and nonetheless received press notice in the *Gazette des Beaux-Arts* and the *Indépendance Belge*. *The Angelus* (Plate III) was sold for 1000 francs and Millet's prices rose.

1860 Millet exhibited at the show rooms of Martinet, who, with other dealers, promoted contemporary artists. In March he signed a contract with the dealers Blanc and Stevens to deliver twenty-five paintings a year at an average price of 1000 to 2000 francs each. This marked a significant shift from the then current practice of living off the sales of a few major works exhibited at the Salon, through which an artist established sufficient reputation to attract smaller private commissions, to the new dealer system, whereby an artist received a virtual income from the dealer in return for all his yearly production, which would then be sold or exhibited by the dealer himself.

1861 *Sheepshearing* (U.S.A., private collection), *Woman Feeding her Child* (Marseilles, Musée des Beaux-Arts) and *Tobit* or *The Wait* (Kansas City, Nelson-Atkins Gallery) were exhibited at the Salon, but only the first received general acclaim. Through Blanc, Millet's works were shown in provincial exhibitions.

1862 A productive year for Millet: dealers exhibited his work at Martinet's show rooms and the Cercle de l'Union Artistique.

1863 At the Salon the *Man with the Hoe* (Plate 29) was bitterly attacked, but Millet allowed it to be photographed and distributed. He began to collect Japanese albums. In November his ninth and last child was born.

1864 The *New-born Calf* (Chicago, Art Institute) was the last truly controversial painting that he exhibited at the Salon, but for this work and two others he was given a first-class medal. *The Shepherdess Guarding her Flock* (Plate 58) turned the tide of criticism in his favour. From the sale of Delacroix's studio he bought fifty sketches.

1865 Emile Gavet, the Parisian architect, began his commissions of pastels. Millet, encouraged by Sensier's journalistic and critical activities, engaged in wide reading in the history of art and in collecting prints, photographs, regional pottery etc.

1866 Millet visited Gruchy to be near his sister during her fatal illness. At the Salon he exhibited a landscape of Normandy, *The End of the Village at Gréville* (Plate 59), which was one of the first exhibited pictures to reflect his increasing interest in pure landscape.

1867 Millet showed nine works from the previous decades at the Exposition Universelle, and this retrospective view secured his reputation. On account of his wife's poor health he visited Vichy and the Auvergne, making ink sketches of the region. His intimate friend and fellow artist, Théodore Rousseau, died after months of illness, nursed by Millet and his wife.

1868 Millet won public honours both in Belgium, where he was made an honorary member of the Société libre des Beaux-Arts, Brussels, and in France, where he was made a Chevalier of the Légion d'honneur. Frédéric Hartmann commissioned Millet to finish works by Rousseau left outstanding at his death and also to paint the cycle of the four seasons (Plates 68–71), two of which were left unfinished on Millet's death. In the summer, Millet again stayed in Vichy, and also made his only trip out of France, to Switzerland, where he studied the paintings by Holbein at Basel.

1869 *Woman Feeding her Child* was sent to the Musée des Beaux-Arts in Marseilles and was probably the first work by the artist to be placed in a public museum. At the Salon he exhibited *The Knitting Lesson* (St. Louis, Art Museum). He added a painting by El Greco to his collection.

1870 In the last Salon of his career, Millet served on the jury and exhibited *Woman Churning Butter* (Malden, Public Library) and *November* (destroyed). In July France declared war on Prussia, and Millet fled with his family to Cherbourg for the duration of the war. Durand Ruel, later the mainstay of the Impressionist group, became his principal dealer, showing works by Millet in London, where he had moved his stock during the war.

1871 In the revolutionary commune, which controlled Paris briefly after France's defeat, a Federation of Artists was set up which included Manet and Courbet. Millet's name was put forward, but he angrily refused the membership. He spent the summer at Gréville and then returned in November to Barbizon.

1872 Durand Ruel exhibited many works by Millet in London, and in public sales his works fetched sums of 15,000 to 20,000 francs.

1873 Sensier sold most of his collection of works by Millet to Durand Ruel and at the Laurent Ricard sale *Woman by a Lamp* was bought for 38,000 francs. Of course the artist himself gained little benefit directly from the rise in prices. Towards the end of the year Millet fell seriously ill.

1874 In May Millet was commissioned to paint some decorations for the Panthéon from the life of St. Geneviève, for which he produced only a few preparatory drawings.

1875 On 3 January Millet's marriage finally received church sanction, and on 17 January the artist died. He was buried beside Rousseau in the cemetery at Chailly (see Plate 56). The contents of his studio were sold on 10–11 May, and the Luxembourg acquired *The Church at Gréville* (Plate VI), *The Bathers* and several drawings now in the Louvre. Emile Gavet's collection of pastels and drawings was sold in June, revealing for the first time that little-known side of Millet's work.

(opposite)
I *The Shooting Stars*
CARDIFF, National Museum of Wales. 1847–48. Oil on canvas 17·7 × 33 cm.

The Shooting Stars and *The Lovers* (Plate 7) reveal a more private use of the nude in Millet's art, and, despite their small size and less imposing media, a passionate and profound sexuality. The figures floating in a starlight space, their bodies dematerializing in liquid paint, suggest that the subject is related to Dante's doomed lovers, Paolo and Francesca da Rimini, whose story is told in *The Inferno*. The tragedy attracted many diverse artists in the nineteenth century, from the classical painter Ingres (1780–1867) in a work of 1819 in the Musée des Beaux-Arts, Angers, to the Pre-Raphaelite Rossetti (1828–1882) whose triptych of 1855 (London, Tate Gallery) also contains floating figures in a starry space. In the almost Expressionistic treatment of the faces built up by lighter paint over a warm-toned ground, one can also detect the influence of Delacroix, who had made his Salon début in 1822 with a Dantesque subject, *The Barque of Dante* (Paris, Musée du Louvre).

I *Self-portrait*

CHERBOURG, Musée Thomas Henry. 1841. Oil on canvas 73 × 60 cm.

Millet returned to Cherbourg in the winter of 1840 following the success of having one portrait (*M. Lefranc*, Zürich, Nathan collection) accepted at the Paris Salon of 1840. This early self-portrait shows the young peasant aspiring to bourgeois respectability in his dark frock coat and brilliant white linen. The mien and gaze and the use of strong contrasts in the painting, however, reveal a tense and determined personality. Discontent vies with defensiveness in the solemn almost sullen expression.

(opposite)
II *The Sower* (see Plate 19)
BOSTON, Museum of Fine Arts (gift of Quincy Adams Shaw)

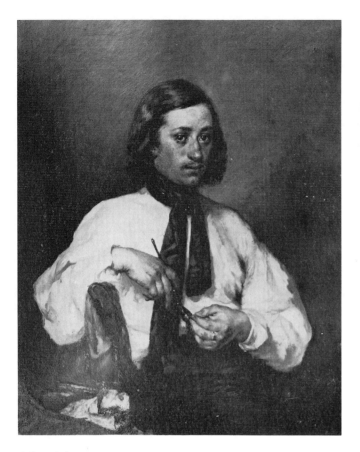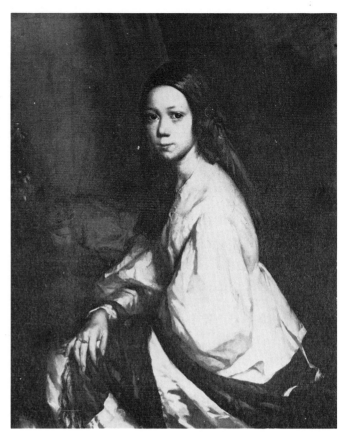

(above left)
2 *Portrait of Armand Ono*
CHERBOURG, Musée Thomas Henry. 1843. Oil on canvas 100×81 cm.

Millet's move away from his severe style is evident in this superbly rich and colourful portrait of
his brother-in-law and friend. Colour, laid onto a red-brown warm-toned ground with a loaded
brush, establishes the forms and the vibrant atmosphere. The expanse of the blouse, modelled
with blue-grey shadows, and the lumpen fleshiness of the hands are masterful pieces of painting.
The casual pose and informal dress anticipate the abandonment of bourgeois life evident in Millet's
own self-portrait two years later (*frontispiece*).

(above right)
3 *Portrait of Pauline Ono en déshabillé*
CHERBOURG, Musée Thomas Henry. 1843. Oil on canvas 100×80 cm.

Millet married this young woman in Cherbourg in November 1841 and returned with her to
Paris, where she died of consumption in 1844 at the age of twenty-three. He had painted her before
their marriage (*Pauline Ono in Blue*, 1841, Cherbourg, Musée Thomas Henry), in the style of his
early portraits of the Cherbourg bourgeoisie, with strong contours, clean lines and austere colour.
This later work is more intimate and sensuous, revealing Millet's growing interest in the more
painterly styles of French eighteenth-century art and Spanish painting in his use of freer surfaces
and fuller shapes. With the pyramidal silhouette of Pauline's figure, Millet set up contrasting
rhythms of her loosened clothes and swivelling torso and created an emotional tension between the
womanly fullness of those curves and her sad expression and the gentle timidity of her still girlish
face. In type, this portrait recalls those of Saskia by Rembrandt, but it has been touched by
the melancholy temperament of the artist.

(opposite)
4 *Woman at a Window*
CHICAGO, Art Institute of Chicago (Potter Palmer collection). 1844–45. Oil on canvas 52·1 ×
62·4 cm.

The painterly tendencies in Millet's work reached their apogee around 1844 with a style which
Sensier called 'sa manière fleurie' ('his flowery manner'). The luscious colour and powdery paint
of this style is evident in the portrait *Antoinette Hébert before a Mirror* (U.S.A., private collection,
1844–45), which reveals Millet's debt to Velázquez and the Venetian tradition, transmitted from
Titian and Veronese, via Correggio and Prud'hon to Millet's immediate contemporary, Narcisse
Diaz. Millet's work of this period was specifically compared by critics to that of Diaz, whose
Descent of the Gypsies (Boston, Museum of Fine Arts) was exhibited at the Salon of 1844, and the
palette and treatment of *Woman at a Window* show the influence of Diaz. The subject, however,
marks a departure from portraiture to the pastoral and erotic genre of nymphs and nudes which

became increasingly dominant in Millet's work after a trip to Le Havre in 1845. Although such light subjects had occurred in Millet's work before this date, they multiplied thereafter, possibly as a result of the acceptance by the Salon of 1844 of two such themes in pastel, *The Riding Lesson* and *The Milkmaid* (both lost). In this painting, we can see Millet continuing the 'flowery manner', in the light-hearted colours and the loaded brush, but the picture also illustrates Millet's growing interest in the human form. The pose itself recalls the painting by Rembrandt, *Girl at a Window* (London, Dulwich Art Gallery), but for once Millet seems less serious, more immediate and light-heartedly piquant.

(overleaf)
5 *Oedipus Taken Down from the Tree*
OTTAWA, National Gallery of Canada. 1847. Oil on canvas 136 × 77·5 cm.

During his first years in Paris, Millet had attended the atelier of Delaroche in the Ecole des Beaux-Arts, where he studied to become a painter of historical and classical subjects. He had unsuccessfully competed for the coveted Prix de Rome in 1839, but subsequently turned his hand to ambitious religious and classical subjects which also met with little success. *Oedipus* was, in fact, painted over one of these, *The Temptation of St. Jerome* of 1846, of which only a macabre fragment of a skull survives (Zürich, Hüber collection). Millet's pastoral or erotic nudes of the 1840s appear again in this painting, but endowed with more classical and serious overtones in which references to Michelangelo and Poussin are discretely suggested. The most immediate influence, however, was Eugène Delacroix (1798–1863), whose *Massacre at Chios* (Paris, Musée du Louvre, 1824) contains a direct source for Millet's foreground female nude. The dramatic chiaroscuro of Millet's facial modelling, moreover, derived from Delacroix's *Medea* (Paris, Musée du Louvre, 1838). The composition is that of a traditional representation of the Descent from the Cross, which Millet converted to a pagan theme, initiating a shift from biblical to secular subjects, which later included a transition from historical to contemporary themes. The most radical development in this painting was the paint itself, dry, brutal and thick to the point of relief in certain passages. Critics noted this 'unbelievable audacity and energy'.

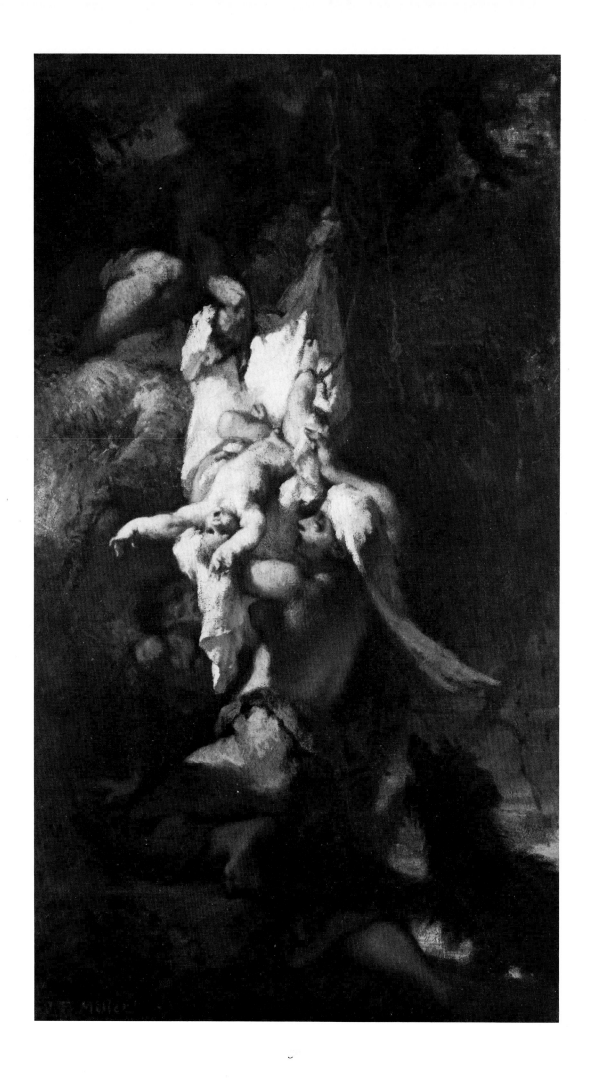

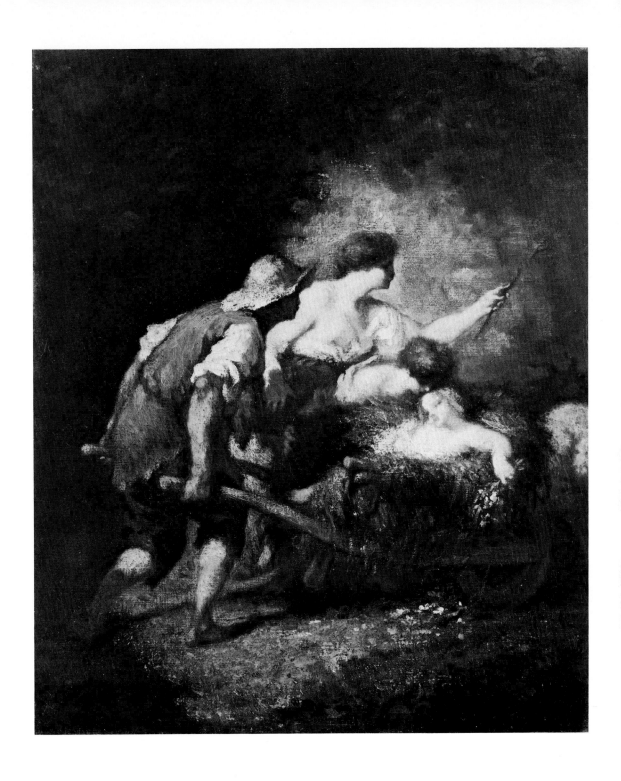

6 *The Return from the Fields*
CLEVELAND, Cleveland Museum of Art (purchase, Mr. and Mrs. William H. Marlatt fund). 1846–47.
Oil on canvas 45·7 × 38·1 cm.

The influence of French eighteenth-century painting lies behind this pastoral, particularly a work
by Fragonard and Marguerite Gérard, *The Cherished Child* (fig. 5). Francis Haskell suggests a
closer source in Fragonard's *Vow of Love*, which was exhibited in Paris at an exhibition in 1848 and
would thus imply a later dating for this work. Indeed, the drier and thicker paint and figure style
can be related to other works of 1847–48 such as the *Oedipus* (Plate 5) and *The Winnower* (U.S.A.,
private collection, 1848). The significance of this painting lies in its rural theme, prefiguring
Millet's later preoccupations, but at this date his style was still cast in a traditional form deriving
from an eclectic study of the art of the past. Francis Haskell in *Rediscoveries in Art* has analysed the
revival of interest during the 1840s in the idiom of the eighteenth century and has shown that its
supporters were often left-wing nationalists, such as Thoré, who, in an article in 1836, coined the
phrase 'radicalism, rococo and national glory'. Something of the complexity of the artist's search
for style in the 1840s can be seen by juxtaposing Millet's apparently historicizing pastoral with the
possibility of a contemporary political significance of the eighteenth-century source.

(above left)
7 *The Lovers*
CHICAGO, Art Institute of Chicago (Charles Deering collection). 1848–50. Black crayon on yellowish paper 32·4 × 22 cm.

The medallion shape and entwined figures suggest a classical bas-relief, for the drawing has a sculptural feel. Millet's nudes inspired many later sculptors like Dalou, Meunier and Degas, but it is the monumental sculpture by Auguste Rodin (1840–1917), *The Kiss* (London, Tate Gallery, 1880–82), which is the direct descendant of Millet's frank portrayal of human sexuality in an admirably beautiful formal composition.

(above right)
8 *The Old Woodcutter*
PARIS, Musée du Louvre, Cabinet des Dessins. 1845–47. Black crayon on beige paper 40 × 28·6 cm.

Millet's drawings of rural subjects in the mid-1840s show a greater degree of naturalism than his paintings. Nonetheless, sources can be listed which include a northern graphic tradition of Bruegel's and Holbein's series of Crafts and Cries of Paris and late Gothic misericords with their preoccupation with death. The subject of the faggot bearer and the gaping mouth, bent posture and angular profile anticipated Millet's treatment of the misery of the human condition in the 1850s, while showing the formal sources to which the artist looked in the 1840s to find the means to give expression to his fatalistic philosophy.

(opposite)
9 *Roadbuilders of Montmartre*
TOLEDO (OHIO), Toledo Museum of Art (gift of Arthur J. Secor). 1846–47. Unfinished oil on canvas 74 × 60 cm.

This energetic presentation of force and physical labour is in direct contrast to the monumentality achieved in the previous plates. The paint was applied more fluidly, almost graphically enlivening the whole surface, while strong contrasts of light and shade play over the figures, dramatizing their exertion. Detail was sacrificed to overall silhouette and no attempt was made to ennoble or prettify the poses or faces. Sensier reported Millet's justification for his 'ugly' peasants: 'They say that one does see handsome peasants and pretty peasant girls—indeed but their beauty resides not in their faces—but it emanates from the total effect of a figure and their actions Beauty is expression.'

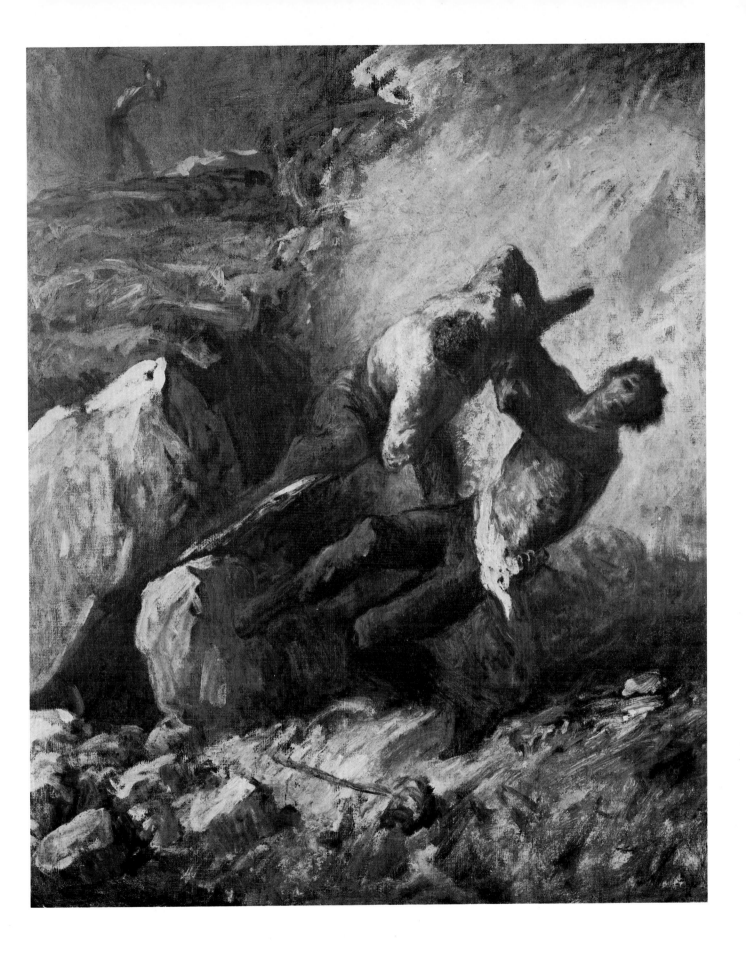

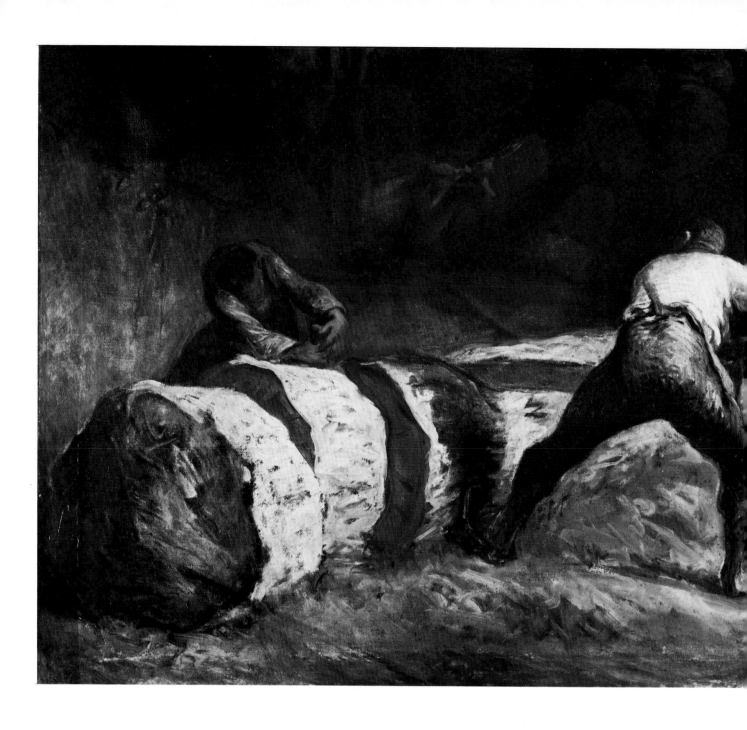

10 *Woodsawyers*
LONDON, Victoria and Albert Museum. 1848. Oil on canvas 57 × 81 cm.

For the subject and models for the *Woodsawyers* and the *Roadbuilders of Montmartre* Millet looked to the activities of the *banlieue* of Paris, a twilight zone of semi-rural, semi-urban life which came into being as the population of Paris was swelled by peasant migration to the city, in whose fluid and disinherited numbers the bourgeois of Paris saw the most threatening of 'les classes dangereuses'. However, the accompanying drawing (Plate 11), a study for this composition, shows it to be a studio work and a depiction of physical activity. In comparing the two works, one can see how the worker on the right became more squat in the oil, his weight lowered and balanced on the pyramid formed by his widely placed and solidly braced legs, while the left-hand sawyer became more compressed to convey the effort of drawing the saw through the log, thus losing the grace of his counterpart in the drawing. The vigorous use of lighting and liquid oil paint invites comparison with the work of Millet's contemporary, Honoré Daumier (1808–79), for instance *The Robbers and the Donkey* (Paris, Musée du Louvre, 1848–50).

11 *Woodsawyers*
BAYONNE, Musée Bonnat. Pencil 25·5 × 41·1 cm. Study for Plate 10.

12 *Sheepshearers*
PLYMOUTH, City Art Gallery. 1846–48. Black crayon on beige paper 30 × 35·5 cm.

This is probably the earliest treatment of a theme that recurred throughout Millet's *oeuvre*, for instance the large oil of 1860 (U.S.A., private collection), a plate in the series of *Labours of the Fields*, engraved in 1853, and the 1854 pencil drawing, now in the Metropolitan Museum of Art in New York. We can thus establish the continuity of theme in Millet's art, but the drawing is, in addition, typical of the pastoral, rural subjects of the early period by virtue of its emphasis on the figures, with minimal background detail, the closed and sculptural composition and, as Herbert comments (Herbert, 1976), the picturesque tendency in the depiction of the peasants and their task.

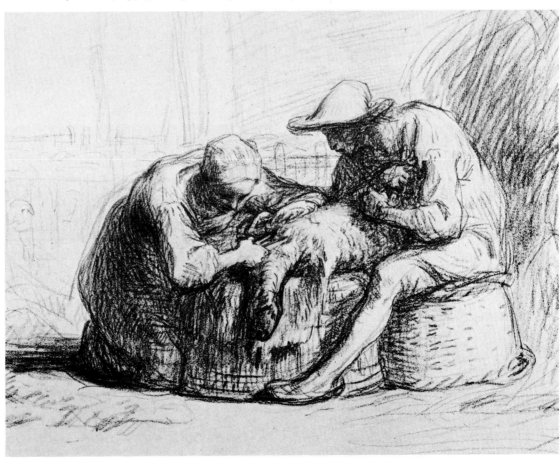

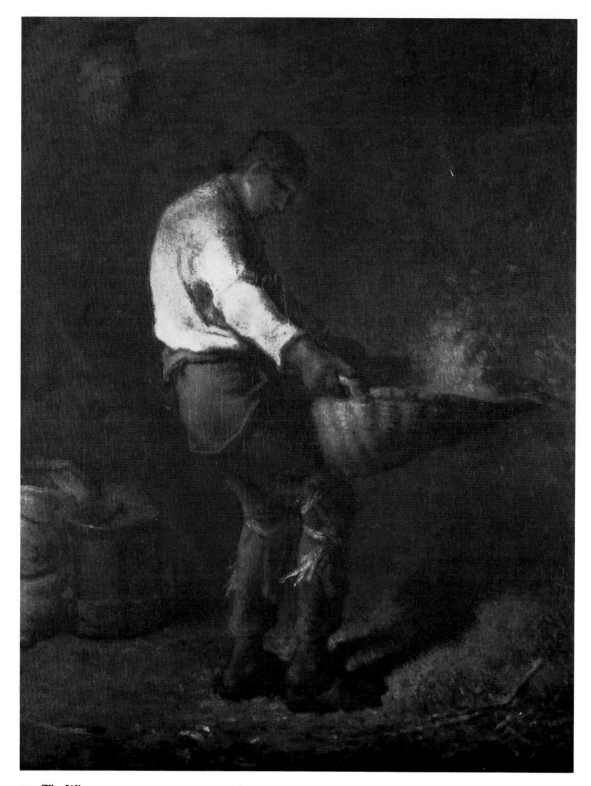

13 *The Winnower*

PARIS, Musée du Louvre. 1853–57. Oil on canvas 38·5 × 29 cm.

Millet's great Salon success of 1848 was purchased by Ledru Rollin and thereafter disappeared
from public view. Until 1974 this crucial work could only be reconstructed with the help of the
version reproduced here and a yet later variant of 1866–68 (Paris, Musée du Louvre). However,
the lost *Winnower* was recently rediscovered in an American private collection (Lindsay, *The
Burlington Magazine*, 1974), cleaned and exhibited for the first time since 1848 in Paris and London
in 1975–76, although for legal reasons it has proved impossible to reproduce in this book. *The
Winnower* illustrated here contains the major compositional elements of the original *Winnower*, but
lacks the force of the latter's dramatic transitions from a luminous white shirt to a dusky back-
ground which serve to throw forward the powerfully musculated figure and highlight the fleshy
grip of the hand on the basket, which celebrates the strength of the act of labour. Moreover, in the
later versions all traces of the 'manière fleurie' of the mid-1840s, which had survived into the 1848
version in a golden curtain of grain thrown up by the basket and the subtle red of the bonnet, had
been erased. The rediscovery of *The Winnower* of 1848 confirmed Gautier's description of its notable

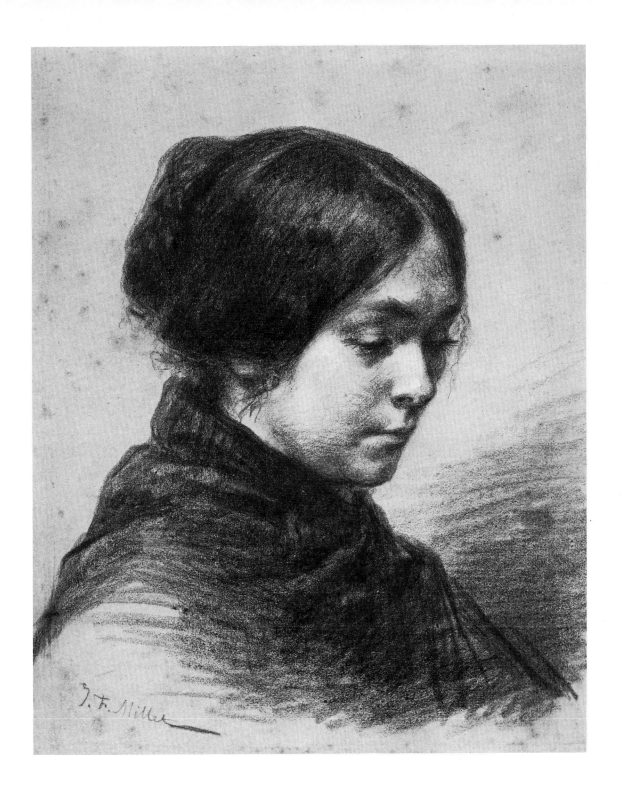

colouration, with the pink-red of the bonnet, the white of the shirt and the blue of the leggings. It is to be hoped that this marvellous work will someday be on view again, thus restoring to us a key painting which is the culmination of Millet's researches of the 1840s and which subtly prefigures the epic figure subjects of the 1850s.

14 *Portrait of Catherine Lemaire*
BOSTON, Museum of Fine Arts (gift of Mrs. H. L. Higginson). 1848–49. Black crayon on blue-grey paper 55·8 × 42·8 cm.

Catherine Lemaire (1827–1894), a servant girl Millet met in Cherbourg, became his companion in 1844, after the death of his wife. She bore him numerous children before their civil marriage in 1854, and their union only received church sanction on Millet's deathbed in 1875. She served as Millet's model for many of his paintings and drawings of peasant women at work. In this portrait drawing Millet had already begun to transform her youth into the more substantial proportions that characterize his images of the woman worker.

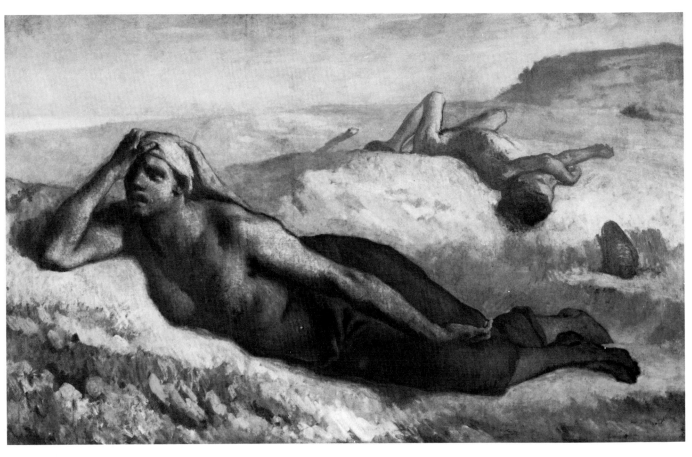

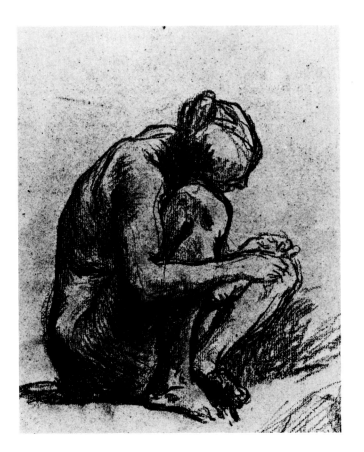

(above)
15 *Hagar and Ishmael in the Desert*
THE HAGUE, Rijksmuseum Mesdag. 1848–49. Oil on canvas 145 × 233 cm.

This work was intended to satisfy the commission Millet had received from the state in 1848, but it was never submitted either to the state or for public exhibition. It may have been left unfinished, therefore, although it is difficult to imagine the picture being in any other state than it is. Why Millet abandoned it in favour of *The Harvesters* (Paris, Musée du Louvre, 1850) has never been clear. It is interesting to compare the similarities in monumental scale and the fluid, rich paint of the studies of mothers and children used by Daumier and Millet as their submissions for the competition for an allegorical figure to represent the new Second Republic with Hagar and Ishmael, cast out into the desert without nourishment. Perhaps behind this biblical subject there was an allegorical intention that Millet abandoned when he left Paris in June 1849 for Barbizon.

(left)
16 *Seated Nude*
BREMEN, Kunsthalle. 1848–49. Charcoal on grey paper 19·5 × 15·7 cm.

Studies on the reverse of this drawing showing the nude figure of Hagar suggest that this nude may also be connected with the painting. However it is remarkable in itself for the pathos conveyed by the crouching and ageing figure, a quality one can also find in works by Rodin, for instance *She Who Was Once the Beautiful Helmetmaker's Wife* (New York, Metropolitan Museum of Art, 1885), and in the work of van Gogh, whose drawing of a seated, pregnant, naked woman, *Sorrow* (fig. 3), has similar pathos and grandeur and was drawn by the artist with a work of Millet in mind.

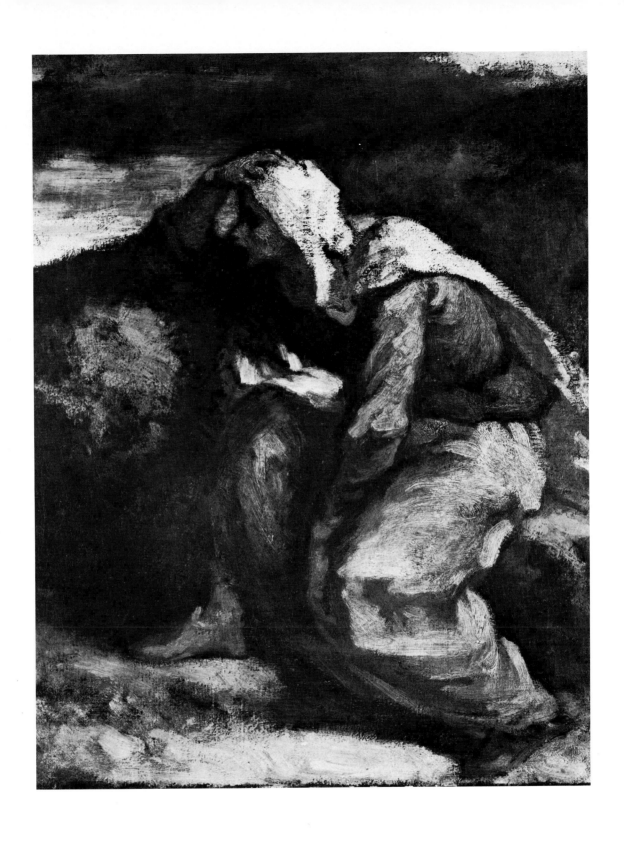

17 *The Fisherman's Wife*
THE HAGUE, Rijksmuseum Mesdag. c. 1849. Oil on canvas 47·5 × 38·5 cm.

The dryness of the paint and its rugged application parallel Millet's style in *Oedipus* in which the same facial type also appears. This subject, a woman looking out to sea, searching, with alternating hope and despair, the empty horizon for the speck of her returning husband's or son's ship, was often treated by genre painters, especially in Holland as, for instance, in the work of Josef Israels (1824–1911). The solid gravity and air of pervading tragedy, however, look back to Michelangelo's Sibyls on the Sistine Chapel ceiling. The single monumental figure illustrates Millet's admiration for Michelangelo, who could convey the condition of humanity in a single figure.

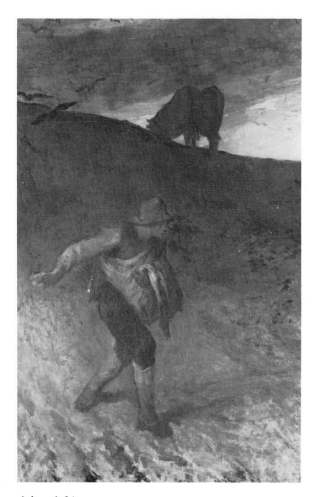
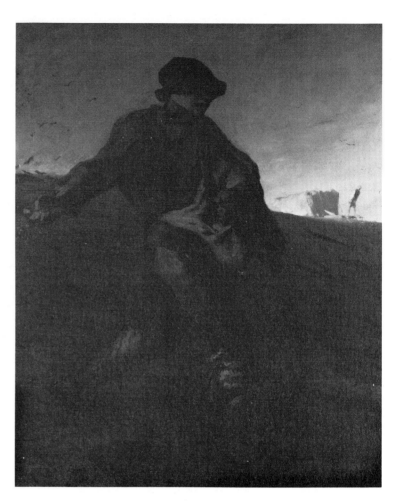

(above left)
18 *The Sower*
CARDIFF, National Museum of Wales. 1846–47. Oil on canvas 94 × 60 cm.

This is the earliest of many versions of the theme of the sower and may have originated in the biblical parable. The figure is set against the bleak hillsides of Millet's native Normandy, but the figure is small, cramped and almost dwarfed by the surroundings. The awkward pose and the angular contours of the sower can be compared to the expressive and dramatic silhouettes of Millet's portrayals of labour in this period (Plates 8–12).

(above right)
19 *The Sower* (see Plate II)
BOSTON, Museum of Fine Arts (gift of Quincy Adams Shaw). 1850. Oil on canvas 101 × 82·5 cm.

This painting marks the beginning of the monumental images of the peasant in large oil paintings of the 1850s which Herbert (1976) calls 'epic naturalism' and Lepoittevin (1973) sees as a symbolic return to the earth. The tragic grandeur of *Hagar*, the brutal surfaces of *Oedipus* and the rustic theme of *The Winnower* are synthesized in this bold image. The striking difference between this and the earlier *Sower* (Plate 18) lies in the enlargement of the figure in relation to its surrounding space and in the energy of the paint work. Clark (1973) suggests that its very forcefulness is the reason why Millet did not dare exhibit this version. Another explanation is based on the fact that the hand comes too close to the left-hand edge of the canvas, bringing the whole figure forwards and dangerously close to the spectator's world.

(opposite)
20 *The Sower*
PHILADELPHIA, Provident National Bank. 1850. Oil on canvas 101 × 80·7 cm.

In this version of the theme of the sower, exhibited at the Salon of 1850–51, yet a further change in the series was made. The figure is more contained by space around it, the colours are subdued, particularly the deadening of the pink light of the sunset on the horizon, the paint is drier and the surface thinner. Thus image and background, paint and surface are more fully integrated. However, it is hard to assess these effects for the painting may have been cleaned and relined thus flattening and compressing the surfaces. Around the figure itself there is a ghostly shadow which follows the silhouette of the sower. This could be the outline of the figure as originally painted but moved, in the final state, some centimetres to the right, suggesting that it was this version in which the proportions were incorrect. Whatever the cause, the overall effect of the exhibited work is considerably less vigorous and more sullen; it seems closer to *The Winnower* and its precedents and less drastic than the great Boston version.

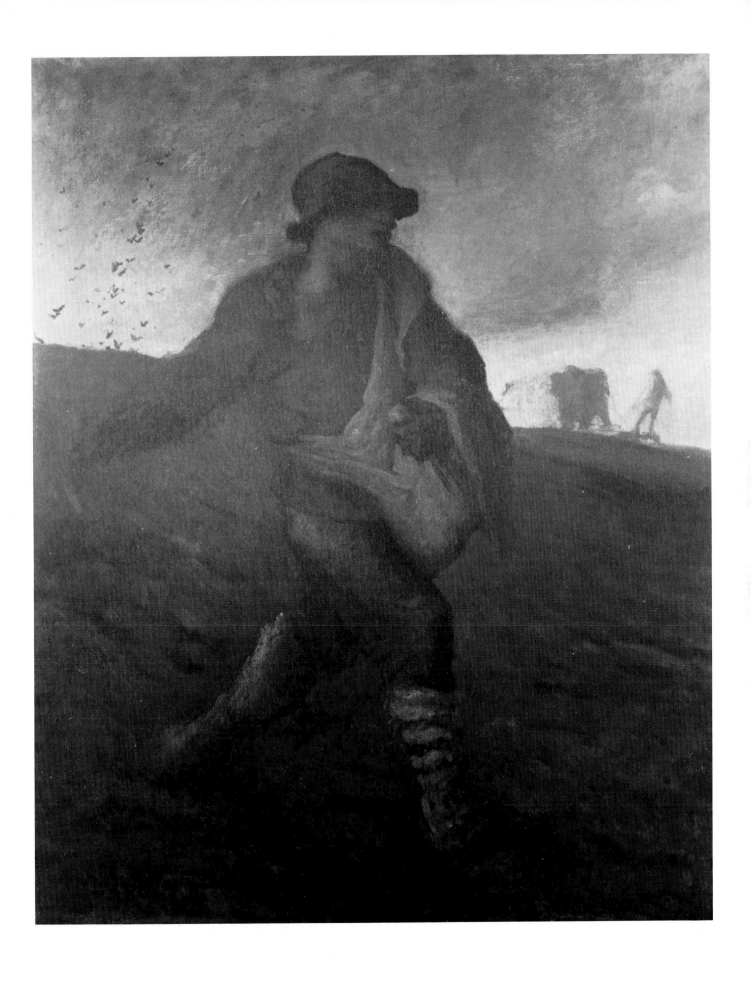

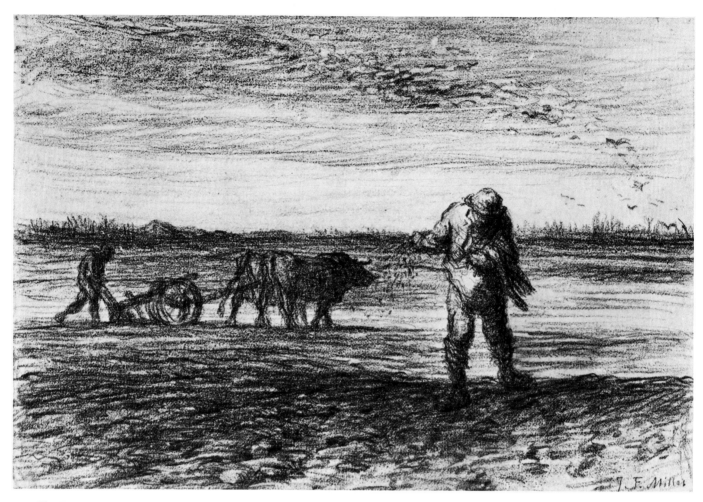

21 *The Sower*
OXFORD, Ashmolean Museum (bequest of P. M. Turner). 1850–51. Black crayon 14·6 × 21·2 cm.

For the first time the flat plains to the south of Barbizon were used in this drawing as a setting, and the sower and harrow serve a compositional purpose in punctuating the horizontal planes of the receding landscape. The sower himself is drawn with energetic and repeated lines, while the play of light over his form throws into relief the almost pregnant protrusion of the seedbag he carries round his waist. In this series of four versions of the same motif of the sower one can both appreciate the importance of the theme to Millet in this crucial period of transition from eclecticism to his mature style and subject matter and note the variety of pictorial devices and the technical subtleties of different media through which Millet searched for the means and style appropriate to an image.

(opposite)
III *The Angelus*
PARIS, Musée du Louvre. 1855–57. Oil on canvas 55·5 × 66 cm.

The Gleaners of 1857 showed a new interest in landscape, also noticeable in *The Angelus*, in which the two figures are set in a wide plain and suffused with the glow of the setting sun. Portrayals of peasant piety were not unusual in nineteenth-century painting, and in 1859 Alphonse Legros exhibited a painting entitled *The Angelus* (formerly Cheltenham, collection of Mr. and Mrs. Asa Lingard) which was, however, set inside a church. Millet juxtaposed the place of formal worship and the peasants at their labours and thus introduced many layers of possible meaning. *The Angelus* became a cause célèbre in the nineteenth century, and the varying fortunes of the painting reflected those of the artist. Commissioned by an American who failed to collect the finished canvas, it changed hands repeatedly during the 1860s, coming to rest for a while with Emile Gavet, the Parisian architect who became an important patron of Millet in 1865. In the early 1870s *The Angelus* appeared on the market again, with fluctuating prices, but in 1889, at the famous Secrétan sale in Paris, it was finally sold to America for 553,000 francs, after the French bidders had failed to raise the money necessary to win it for the Louvre and the Chamber of Deputies had voted against supplying the funds themselves. *The Angelus* returned to France in 1909 when a French shop magnate, Chauchard, made his bequest to the Louvre, having purchased the painting in America for 800,000 francs. As Millet's reputation began to decline after 1910 *The Angelus* fell into obscurity from which it was rescued by an unemployed engineer who slashed it. The necessary repairs were visible until the recent restoration inspired by the great revival of interest in Millet, which culminated in the 1976 exhibition of his works in Paris and London.

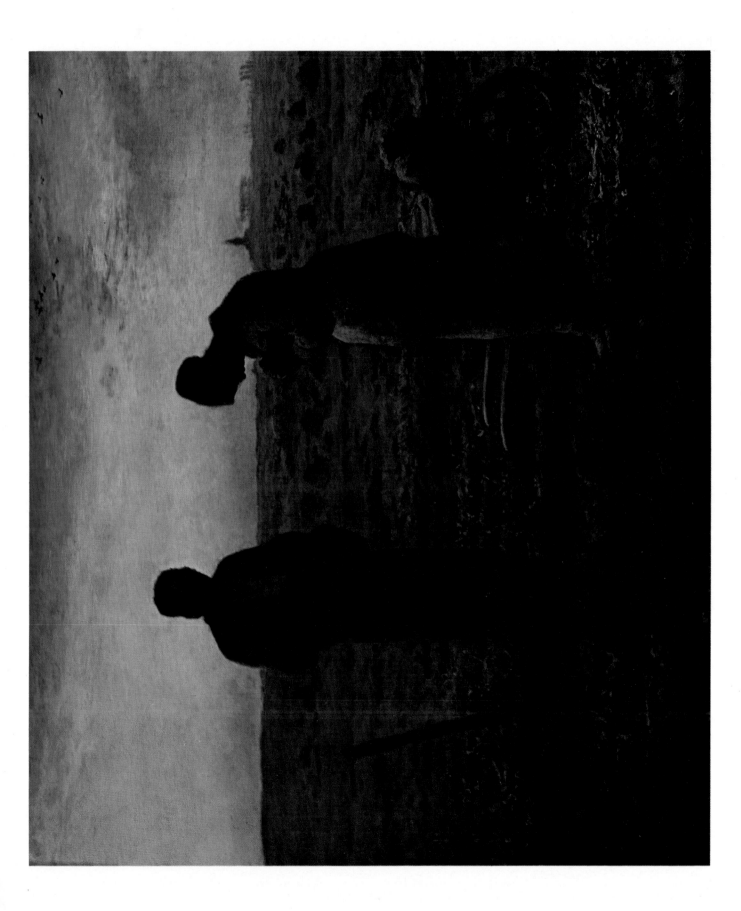

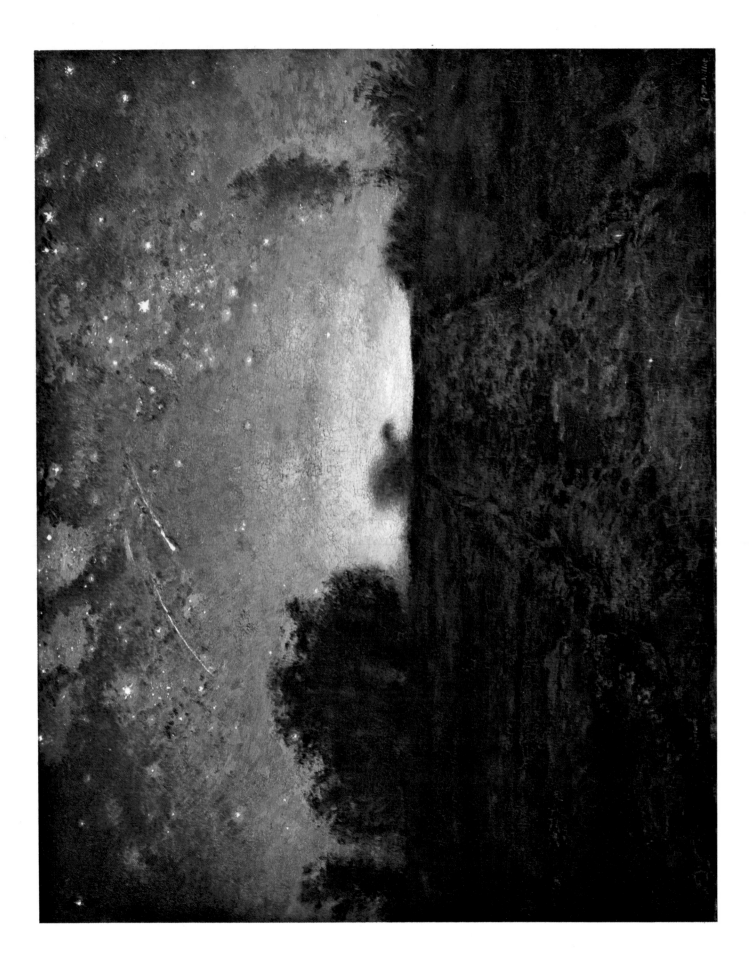

22 *Going to Work*

GLASGOW, City Art Gallery and Museum. 1850–51. Oil on canvas 56 × 46 cm.

The figure of the sower and the female figures of Hagar and the fisherman's wife were put together in a work which has been compared to Masaccio's *Expulsion of Adam and Eve from the Garden of Eden* (fig. 12). There is, however, little doom in Millet's painting. The man walks out across the inclining landscape with vigour, his silhouette enlivened by the rippling contours and peaked cap; the woman's solid and weighty proportions are echoed in the satisfyingly full curves of the basket she carries on her head and from which her face emerges to gaze out of the picture with an almost gentle expression. A later oil version exists (Cincinnati, Art Museum, 1851–53), also an etching of 1863 (Delteil, 1906, no. 20) and a pastel in a private collection in Boston dateable to 1868–70.

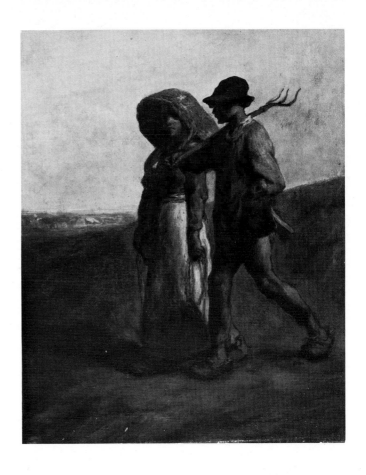

(opposite)
IV *Starry Night*

NEW HAVEN, Yale University Art Gallery (Leonard C. Hanna fund). 1855–67. Oil on canvas mounted on wood 65 × 81 cm.

Once again Millet brilliantly captured the fading light of evening which blurs forms and makes their silent silhouettes strange and full of mystery. Paintings of night, which originated in seventeenth-century northern painting, notably those by Elsheimer and van der Neer, were popular in the nineteenth century, but Millet did not simply portray the moon and monotonous dots of stars as was usual. Instead he painted a variety of shapes, sizes and brilliancies. One modern writer (A. Scheon, *Art Quarterly*, 1971) has linked this treatment with scientific research into astronomy that was published in popular magazines with photographs of new kinds of stars similar to those Millet painted. However, Millet had shown a very early interest in night scenes and repeatedly painted the twilight hour, with its subtle effect of dematerializing forms. The splendours and mystery of the stars and night in this *Starry Night* anticipated the more famous *Starry Night* of 1889 by van Gogh (New York, Museum of Modern Art) which may well have been inspired by Millet. Herbert dates Millet's painting to 1855–67, and in its present state, therefore, it exhibits the stylistic characteristics of both decades. On the one hand there is a strong tonal foundation, while on the other the very rich colours, deep blues, chromes, turquoises and bright greens, anticipated the brilliance of his colouring in the female landscapes of his last decade.

23 *Harvesters Resting*
BOSTON, Museum of Fine Arts (bequest of Mrs. Martin
Brimmer). 1851–53. Oil on canvas 69 × 120 cm.

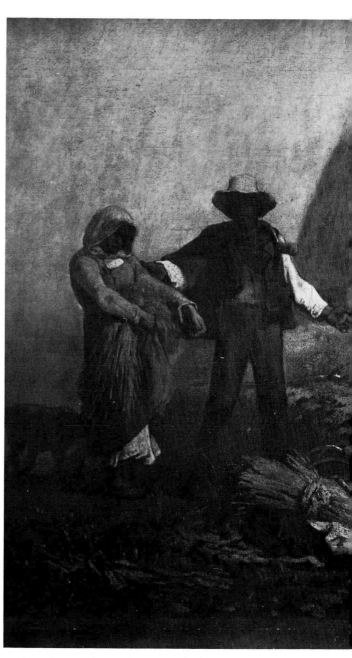

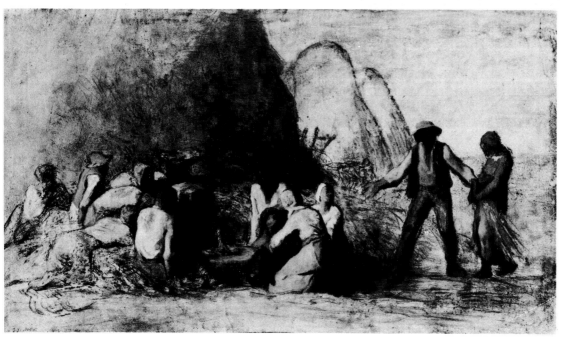

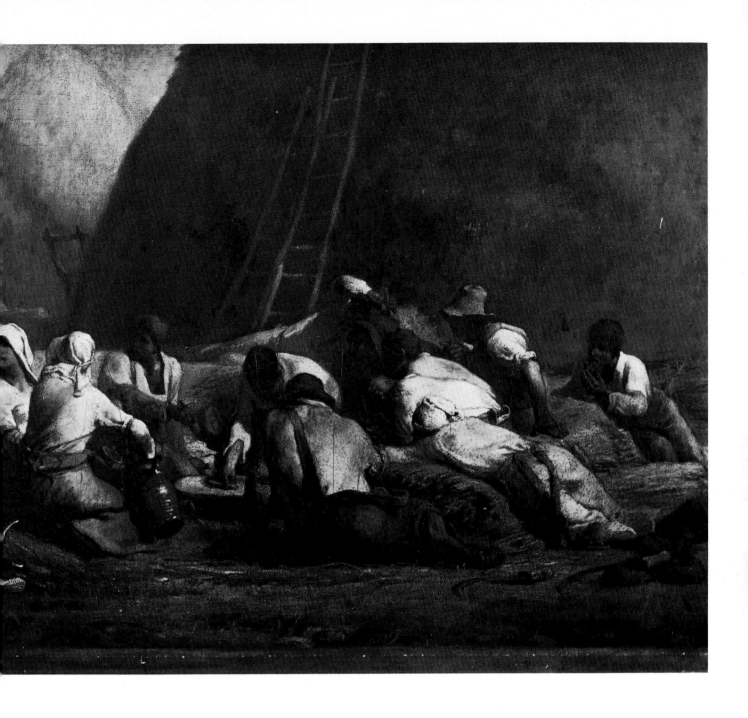

(opposite)
24 *Harvesters Resting*
PARIS, Musée du Louvre, Cabinet des Dessins. 1850–51. Pastel, oil, watercolour and black crayon on beige paper 48 × 86·2 cm.

The pastel study is the most complete of the thirty-nine preparatory drawings for the oil painting (Plate 23) exhibited at the Salon of 1853. In the transposition to the oil, one can see how the energetic line and nervous pattern of chiaroscuro gave way to sculptural solidity and form-enhancing illumination. A contrast of the two principal figures of Ruth and Boaz in the study and the painting shows how Millet eliminated incidental detail for more statuesque effects. Millet changed the original title from *Ruth and Boaz*, with its clear biblical references, to the secular and contemporary *Harvesters Resting* in order to show how the agricultural customs of the ancient world of the Old Testament were paralleled in the habits of nineteenth-century peasant life. The obvious formal debts to the work of Poussin and Bruegel establish a link on another level between biblical literature and its repeated treatment in the history of art.

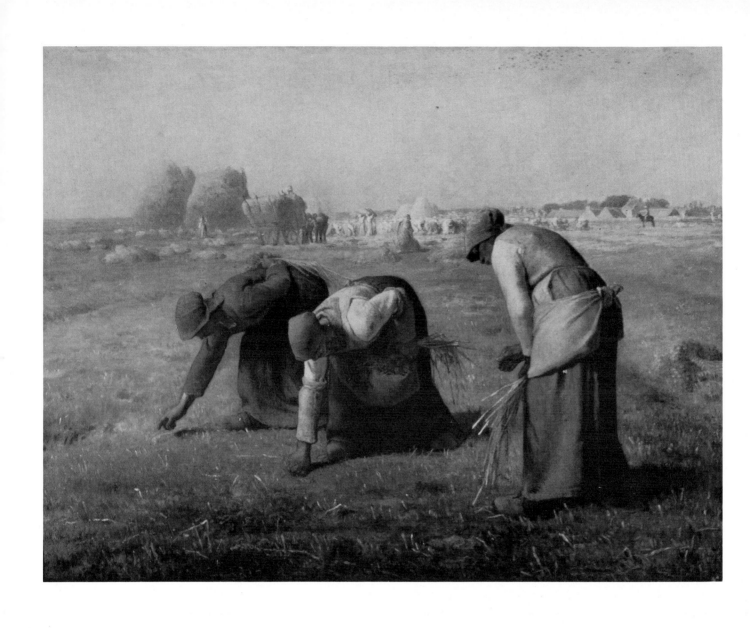

25 *The Gleaners*
PARIS, Musée du Louvre. 1857. Oil on canvas 83·5 × 110 cm.

The Gleaners and *The Angelus* are the most well known and widely reproduced of all Millet's works. The bending figures of the women gleaning became a cliché of peasant painters in the nineteenth century and were quoted in works by Pissarro, Renoir, Seurat and van Gogh.

26 *The Gleaners*
LONDON, British Museum, Department of Prints and Drawings. Black crayon 28·3 × 22 cm.

Herbert (1976) states that this drawing is a finished work done after the earlier painting of 1853, entitled *Summer*, as part of a series of the four seasons commissioned by a friend, Feydeau. As in the epic paintings of the peasant in the early 1850s the figures are set prominently in the foreground of the drawing against a sketchily defined backdrop. The drawing exhibits Millet's use of a clean, single outline for the contour, combined with strong tonal modelling which gives the figures sculptural volume and substance. It is interesting to note that critics compared the women in the final oil painting of *The Gleaners* to the Parthenon frieze, on which outline and the modelling resulting from shallow relief were also used to sculptural effect.

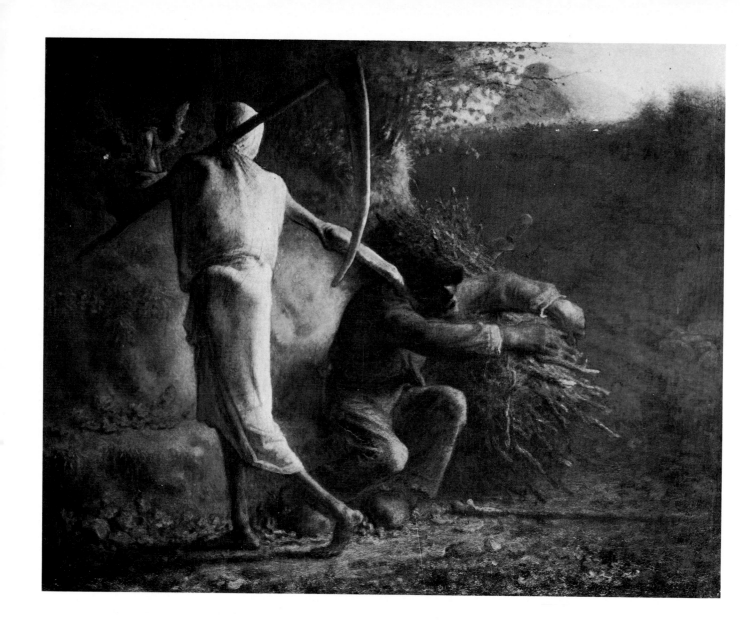

27 *Death and the Woodcutter*
COPENHAGEN, Carlsberg Glyptotek. 1859. Oil on canvas 77 × 100 cm.

Despite the savage criticism of his exhibited works during this decade, Millet continued his attempts to 'disturb the more fortunate in their rest'. He sent to the Salon of 1859 this sombre image of world-wearying labour, which, perhaps understandably, provoked the jury to reject it. In the 1850s forest workers constituted a particularly subversive class, for their landlessness, traditions of collective work and radical class consciousness were potentially explosive at a time when the forests were being taken over by the state or private owners. It may have been felt that Millet's stark painting would have engaged sympathy for the woodcutters. Indeed, when a leftish critic mentioned the refused work in his review of the Salon he roundly stated that 'Millet's woodcutter . . . is not the peasant of 1660 [a reference to La Bruyère] but the proletariat of 1859.' The idea for this painting apparently came to Millet from an observation made in the Forest of Fontainebleau which reminded him of man's fate, weariness. It can be associated with La Fontaine's fable of Death and the woodcutter and, via George Sand, with Holbein's print from *The Dance of Death.* Pictorial analogies can be found in Courbet's *Stonebreakers* (fig. 6), in which the toll taken by work is presented by the juxtaposition of a young man and an old man; in Henry Wallis's *Stonebreaker* (Birmingham, City Art Gallery, 1857) in which the worker has just died at his place of work; and, most intriguingly, in a work by Joseph Wright of Derby that Millet could not have seen which also has a figure of Death passing an old man at work, *The Old Man and Death* (Hartford, Wadsworth Atheneum, 1773).

28 *Death and the Woodcutter*
PARIS, Musée du Louvre, Cabinet des Dessins. c. 1853. Pencil 12·7 × 38·2 cm.

The dating of this study shows how early Millet planned this subject, starting with a small sketch
of the main figures and in additional scribbles working out some of the finer details. In the sketch
the line is nervous and lively, and the insubstantial figure of Death seems to glide by, drawing with
it the fluid form of the seated woodcutter, while the painting achieves more sullen and solid
effects.

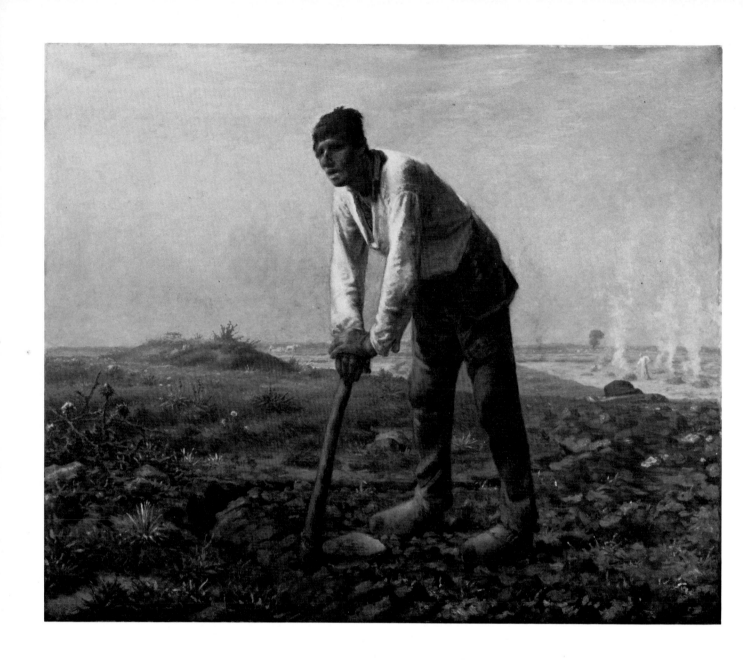

29 *Man with the Hoe*
SAN FRANCISCO, private collection. 1860–62. Oil on canvas 80 × 99 cm.

The worker resting, leaning on his spade, occurred first in Millet's work in 1848–50 (Rotterdam, Boymans-van Beuningen Museum), but this painting, undertaken for the Exhibition of 1863, was based on his monumental figure style of the early 1850s married to the developing emphasis on landscape and environment, dateable to the end of the decade. *Man with the Hoe* became famous after its arrival in America and inspired Edwin Markham's poem of 1899, which begins:

> Bowed by the weight of centuries he leans
> Upon his hoe and gazes on the ground,
> The emptiness of ages in his face,
> And on his back the burden of the world.
> Who loosened and let down this brutal jaw?
> Whose was the hand that slanted back this brow?
> Whose breath blew out the light within his brain?

Such lines, moving as they are, are tinged with a sentimental sympathy that clung to Millet's portraits of peasants, thirty years after these images had been condemned by critics for depicting the peasants as brutal murderers and ferocious beasts.

30 *The Peasant Grafting a Tree*
PARIS, Musée du Louvre, Cabinet des Dessins. c. 1855. Black crayon 18·6 × 15·5 cm.

This is one of the most beautiful of the many preparatory studies for the painting that was exhibited at the Salon of 1855. The painting, although richly coloured, lacks the immense energy and immediacy of the line in the drawing and to some extent justified Baudelaire's strictures on the pedantry of Millet's peasants in the mid-1850s. Millet established a parallel between human and natural fertility by placing the young mother and her child beside the father as he grafts new life onto the old stock.

(above left)
31 *Family near a Window*
LONDON, British Museum, Department of Prints and Drawings. 1851–53. Black crayon and brown wash heightened with white on yellowish paper 26·7 × 21·6 cm.

The delicate intimacy of the subject and its setting against the light of a window recall Dutch seventeenth-century painting, and Herbert (1976) mentions the work of Rembrandt in connection with this drawing. Its calm and quiet, the softness of the drawing and the domestic atmosphere reveal another side of Millet than that which was expressed in oil paintings of this period. Delicate outlines, subtle shading and the hint of colour through light washes were used here to such marvellous effect that one can well understand why Millet's drawings have always found admirers even when his paintings fell from favour.

(above right)
32 *Shepherdess Seated, Holding a Baton*
PARIS, Musée du Louvre, Cabinet des Dessins. 1853. Black crayon 29·5 × 20 cm.

This lovely drawing is a study for a painting of the same subject now in Minneapolis. The young shepherdess was a running motif in Millet's work in all media, but here we see it treated with an astonishingly simple line, a quality that inspired van Gogh, who commented to his brother about another of Millet's line drawings, a woodcut, of a shepherdess, '. . . I thought how much can be done with a single line. Of course I don't pretend to be able to express as much as Millet can with a single contour. But I tried to put some sentiment into this figure' [referring to *Sorrow* (fig. 3)].

33 *Laundresses*
BOSTON, Museum of Fine Arts (bequest of Mrs. Martin Brimmer). 1853–55. Oil on canvas
42 × 52 cm.

No reproduction can do justice to the superb quality of the light and the subtle colours which
convey the simultaneous fading of warm pink sunset and the encroaching grey-blue of twilight.
In black and white, however, one can appreciate 'the remarkable pair of figures, whose meaning is
found not in any detail, not in any facial expression, but in the rightness of their silhouettes, into
which Millet has distilled the essence of their work' (Herbert, 1976). Perhaps the distillation of
which Herbert speaks derived from Millet's ability to express so much with a single contour.
Laundresses both in town and country were a new and 'modern' subject, treated by such artists as
Daumier, Daubigny, who often set his figures against a sunset sky, and, most famously, Degas.

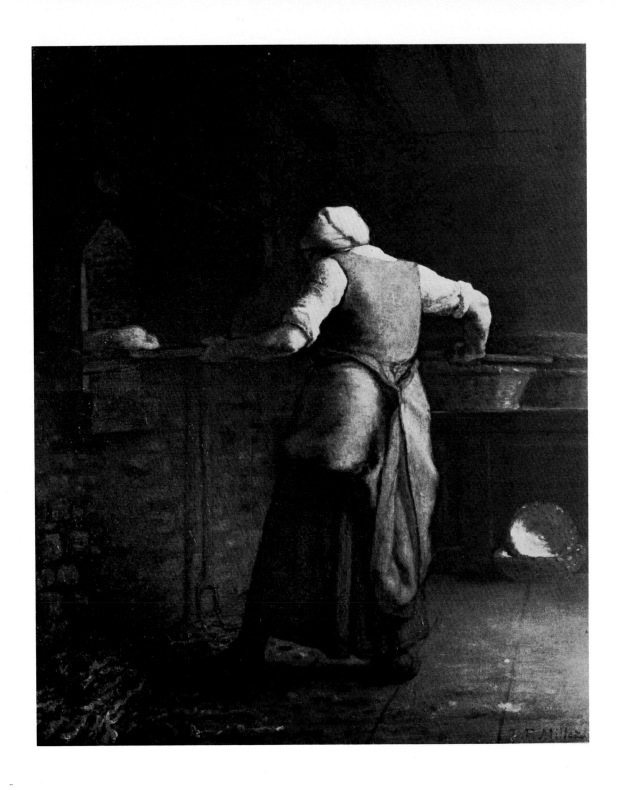

34 *Woman Baking Bread*
OTTERLO, Rijksmuseum Kröller-Müller. 1853–54. Oil on canvas 55×46 cm.

In both drawings and paintings of the 1850s Millet chronicled the daily chores and seasonal activities of the peasants, but his treatment of women and their domestic skills constitutes a distinct and thereby significant group. In this work there is, on the one hand, a sculptural solidity to the figure and Michelangelesque vigour in the action itself, but, on the other hand, the sweet colouring and varnished surface recall the *petits maîtres* of seventeenth-century Holland. Millet's peasant women were different from the usual and idealized portrayals of women at this period because of the frank delineation of the physical strength of the peasant woman and the real effort of her work. Yet, one can detect beneath this apparent realism a personal preoccupation linking these works to his memories of home, of his mother, grandmother and sisters from whom Millet had cut himself off, while they continued to write reproachful and unanswered letters to him. Furthermore there seems to have been a sublimated eroticism attached to these working women which emerges in the disturbingly sexual configuration of this woman's apron.

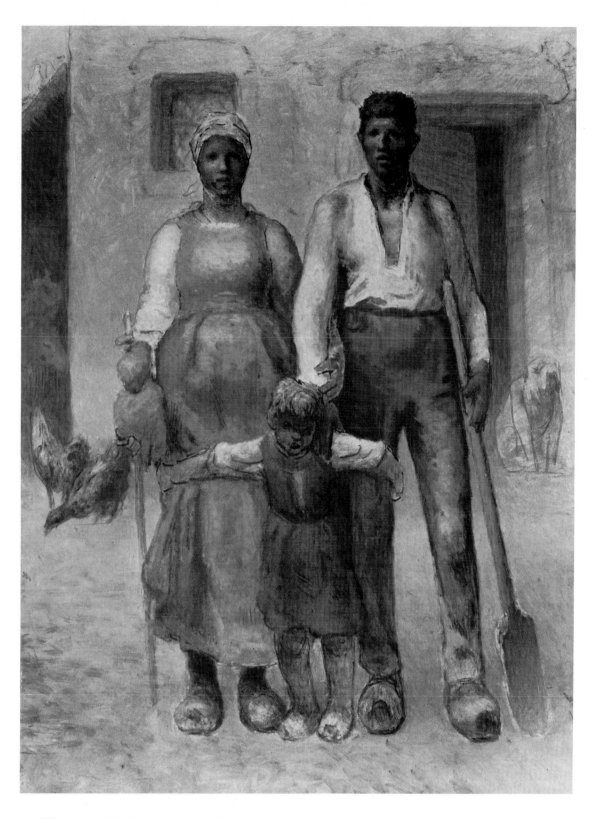

35 *The Peasant Family*
CARDIFF, National Museum of Wales. 1871–72. Unfinished oil on canvas 111 × 80·5 cm.

Once again numerous stylistic and personal sources can be listed for this massive and monumental image of a contemporary Adam and Eve ('When Adam delved and Eve span . . .'). Herbert cites Mantegna's *Parnassus* (Paris, Musée du Louvre), Egyptian reliefs and the photographs of peasants taken outside their homes by itinerant photographers. He also suggests that Millet wanted to pay homage to his recently deceased sister in this work. However, the pose of the woman originated in an earlier oil, *Ceres* (Bordeaux, Musée des Beaux-Arts, 1864–65), but instead of relying upon the allegorical personification of fertility, Millet made his point with a peasant couple joined by the fruit of their union as they lean on their symbolic attributes of spade and spindle. It is interesting to contrast the massive and centred figure of the woman with the contrapuntal rhythms of the man's body and stance, a formal tendency that can be observed repeatedly in Millet's earlier iconography throughout the 1850s.

(above left)
36 *Man with a Wheelbarrow*
LONDON, British Museum, Department of Prints and Drawings. 1855. Etching 16·3 × 13·3 cm.

Millet participated in the revival of etching in France during the 1850s and 1860s with a small
number of very fine prints of which this and *Woman Carding Wool* are examples. His etchings were
inspired by those of the sixteenth century, and he owned prints by Dürer, Lucas van Leyden,
Holbein and Bruegel. Sensier encouraged Millet to make prints in order to reach a wider public.
The subject used here had first been treated in oil in 1848–52 (Indianapolis, Museum of Art).

(above right)
37 *Woman Carding Wool*
LONDON, British Museum, Department of Prints and Drawings. 1855–57. Etching 25·6 × 17·7 cm.

This etching actually preceded the painted version of the subject, exhibited at the Salon of 1863
(Washington, collection of George L. Weil), but it is the print which is the more monumental.
The large figure occupies most of the page and is set in a darkly shadowed interior, reminiscent of
Dutch compositions. The strong, rich blacks and brilliant lights emerging from those shadows
bring to mind the master of chiaroscuro, Rembrandt, whom Millet came to appreciate only very
slowly. The artist told Sensier, 'It was only later that I came to know Rembrandt. He did not
repel me but he blinded me.'

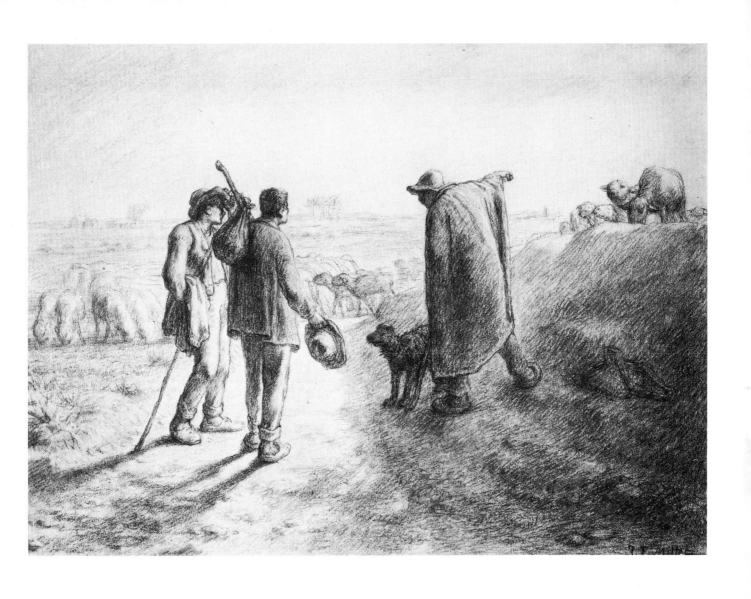

38 *Shepherd Directing Travellers*
WASHINGTON, Corcoran Gallery of Art (W. A. Clark collection). 1857. Black crayon and pastel on yellowish paper 35·5 × 49·5 cm.

It was not unusual for Millet to transpose a biblical anecdote into modern dress and a contemporary situation, as, for instance, in *Harvesters Resting* (Plate 23) or *Going to Work* (Plate 22) and behind the simple scene of a shepherd directing travellers one can perhaps see the story of the pilgrims of Emmaus. Herbert (1976) has suggested that there is a contemporary source for this work in Courbet's proud self-portrait of 1855 *The Meeting* or *Bonjour M. Courbet* (Montpellier, Musée Fabre), in which the artist is deferentially greeted by his patron Alfred Bruyas and his servant, beneath the hot sun of the Midi outside Montpellier. However, if, as Herbert argues, Millet intended to challenge Courbet by using so similar a format, he disguised his purpose, and, by turning the composition around, he drew the spectator's attention away from the figures to the luminous landscape beyond. Yet it is significant that, if Millet was making a statement in reply to Courbet, he chose to identify himself as a shepherd, the most philosophic of the peasants.

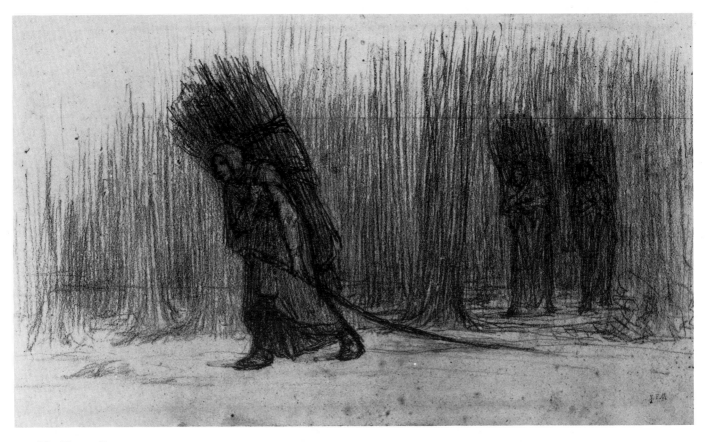

39 *The Faggot Bearers*
BOSTON, Museum of Fine Arts (gift of Martin Brimmer). 1863–64. Black crayon on grey paper
28·9 × 46·9 cm.

With stunning economy and simplicity, Millet conveyed the cold starkness of winter and the
exhaustion of the burdened figures. A screen of black lines suggests the leafless trees, blank paper
the snowy ground. The two women in the middle distance seem to be in the process of emerging
from the forest itself and taking form within the artist's imagination through the network of delicate
lines. This drawing is a fine example of Millet's creative process, and, because the line that defines
the trees and that which shapes the figures are so obviously the same, one can see clearly the idea
of man's and nature's absolute interdependence which Millet's method literally underlines.

(opposite)
V *Winter with Crows*
GLASGOW, City Art Gallery and Museum, Burrell collection. 1862. Pastel on buff paper 70 × 94 cm.

Here is a superb evocation of chill November with the ploughed fields, abandoned tools and circling
crows. November is the season of the sower and a contrast between this panoramic landscape and
The Sower (Plates 19 and 20) of 1850 with its dominating figure and slight background underlines
the new direction of Millet's work in the 1860s. This composition, built up of thin parallel planes,
was based on the Dutch seventeenth-century landscapes of Koninck and on prints by
Rembrandt, although Millet provided a reassuringly solid focus in the central tower and flanking
trees. The polarities of solidity and movement or energy, which Millet set up in figure paintings
between female and male, persist, but here the opposition is between the dense brooding expanse
of the earth and the dynamism of the sky through which the birds wheel, punctuating its expanse
as the harrow and tower articulate the plain below. The pastel is a variant of an 1862 oil painting
(Vienna, Kunsthistorisches Museum) which was engraved by Delaunay, and it was this print that
van Gogh copied in 1890 (Amsterdam, Rijksmuseum).

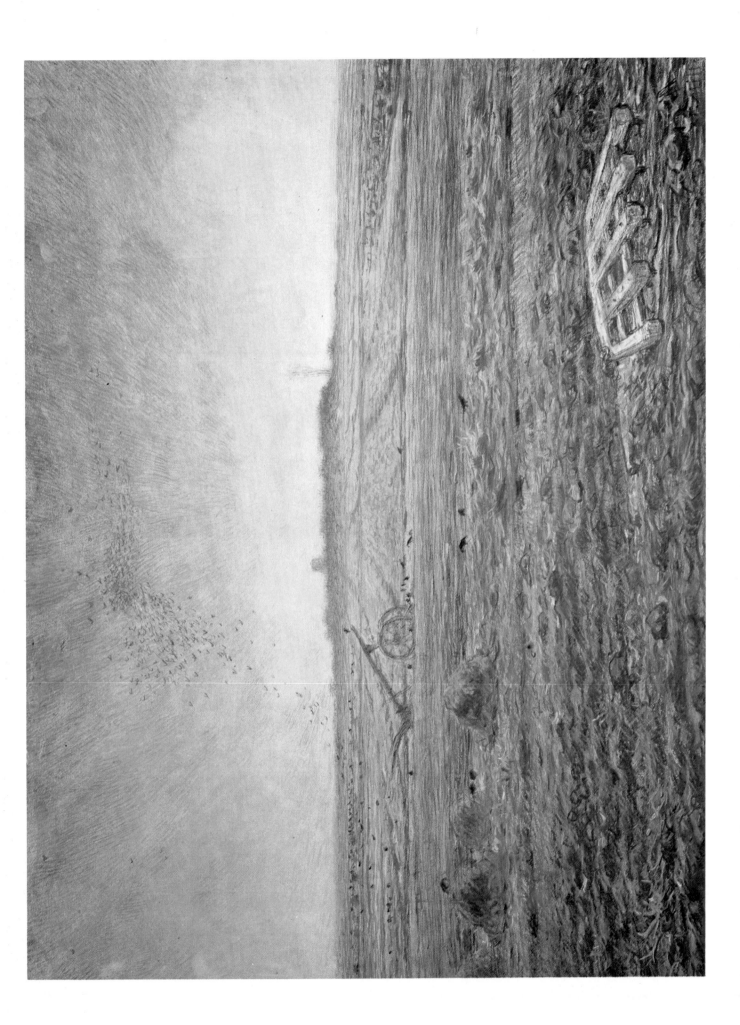

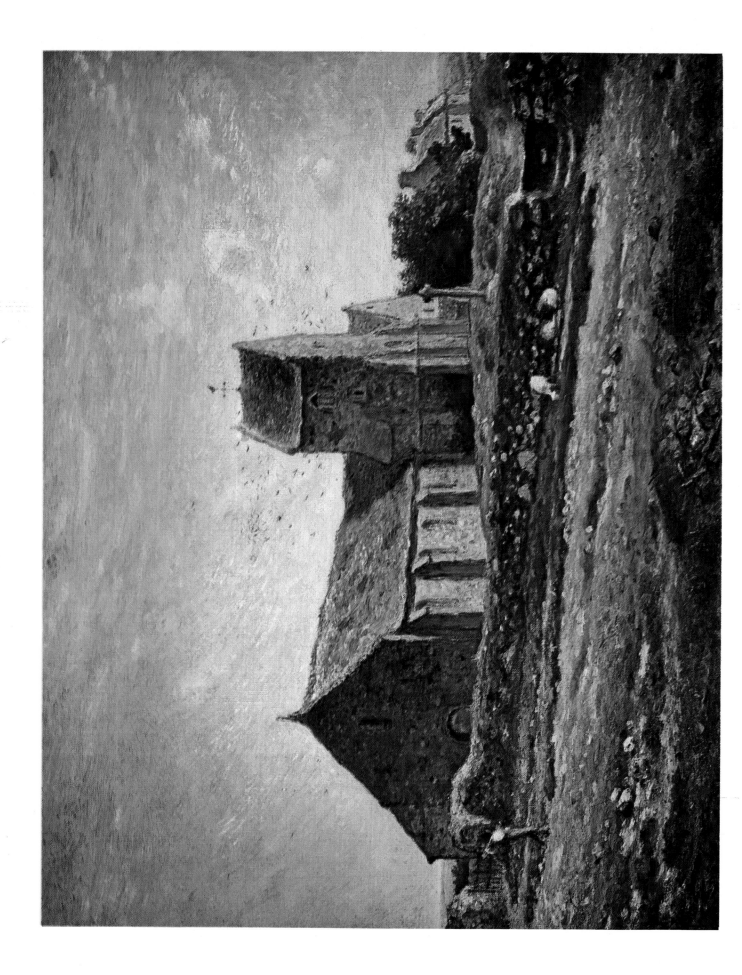

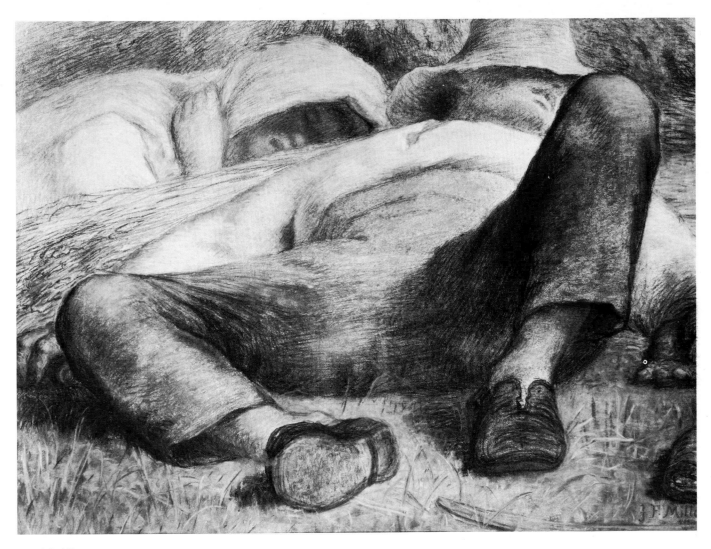

40 *Meridian*
PHILADELPHIA, Philadelphia Museum of Art. c. 1865. Pastel 72·1 × 97 cm.

In 1865 the Parisian architect Emile Gavet began to commission from Millet a series of pastels based on earlier works by the artist illustrating the times of the day and the yearly labours of the fields. When the entire collection was sold in Paris shortly after the artist's death in June 1875, van Gogh visited the salerooms and commented, 'When I entered the room where they were exhibited, I felt like saying, "Take off your shoes, for the place where you are standing is holy ground."' This drawing of the noon rest is remarkable for the sense of physical strength caught in heavy-limbed repose and for its masterly foreshortening. The figure style and theme, related by van Gogh to religious illustrations in medieval devotional books, has been compared to the work of Bruegel.

(opposite)
VI *The Church at Gréville*
PARIS, Musée du Louvre. 1871–74. Oil on canvas 60 × 73·5 cm.

Childhood memories were revived once again in this portrait of the church which played so important a rôle in Millet's life. The church seems disproportionately large in relation to the peasant who walks by, spade on shoulder. The building has a solid and enduring quality reminiscent of the farm houses in the drawing of le Lieu Bailly (Plate 64). However it is the colour in this painting that is most striking. A variety of reds, greens, yellows and blues were applied in tiny dots, dabs and dashes, and it is possible that this technique was influenced by the younger artists who had visited Barbizon in the 1860s and were soon to be known as Impressionists. Equally this lively surface could also be attributed to the effects of Millet's own work in pastel during the previous decade. The painting entered the Luxembourg Museum in 1875 and was, therefore, one of the best known of Millet's landscapes to the next generation. Echoes of it can be found once again in van Gogh's *Church at Auvers* of 1890 (Paris, Musée du Louvre), and Cézanne owned a photograph of it.

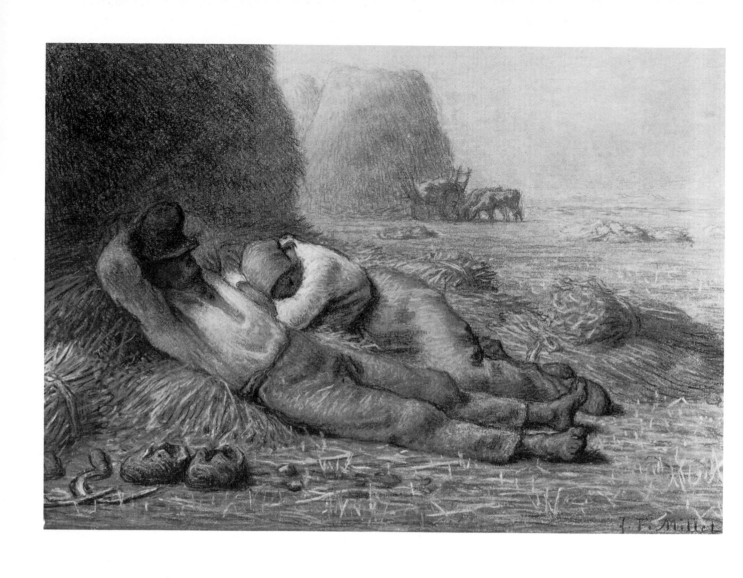

41 *Noon*
BOSTON, Museum of Fine Arts (gift of Quincy Adams Shaw). 1866. Pastel and black crayon
29 × 42 cm.

In 1858, Millet drew four designs to represent the times of the peasant's day, morning, going to
work; noon, the mid-day siesta; twilight, preparing to go home; evening, the family around the
fireside or in lamplight at home. They were engraved on wood by Adrien Lavieille in 1860. *Noon*
and *Evening* (Plate 43), another pastel, were later elaborations of the original drawings, integrating
colour and line through the medium of pastel.

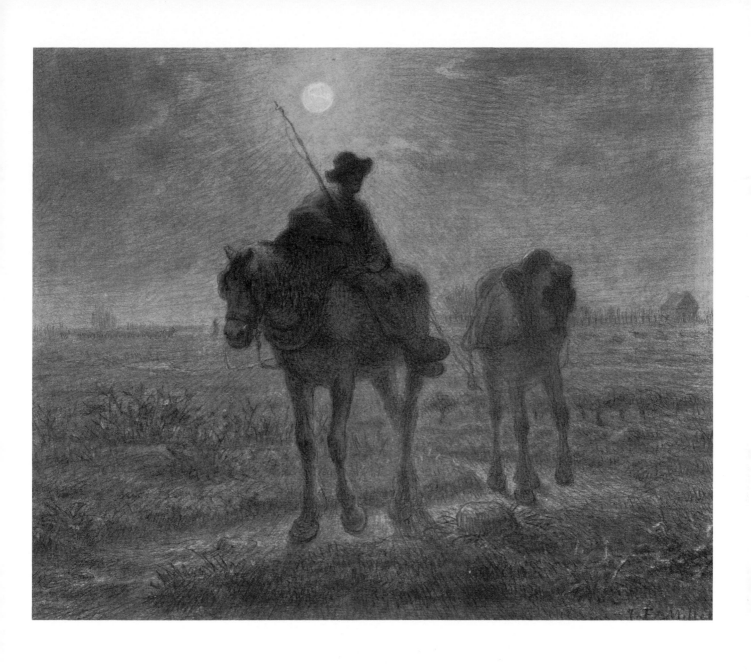

42 *After a Day's Work*
BOSTON, Museum of Fine Arts (gift of Quincy Adams Shaw). 1865. Pastel 37·2 × 45·8 cm.

This is a variant of the theme of evening engraved by Lavieille. Millet captured the slower pace of evening and the quietude of the hour as well as indicating the gentler light of the rising moon. From his youth Millet had loved the twilight and found his own feelings echoed in Virgil's *Georgics*, in which the Latin poet rhapsodized on the 'hour when the deep shadows descend upon the plain'. Twilight brings out the halftones, which Millet, a master of tonal modelling, loved. It softens forms, reducing their detail to simple and expressive silhouettes, and it unifies the whole scene, man, beast and landscape. All these tendencies have already been noted in Millet's work, but they were brought together in this magnificent series of pastels for Emile Gavet.

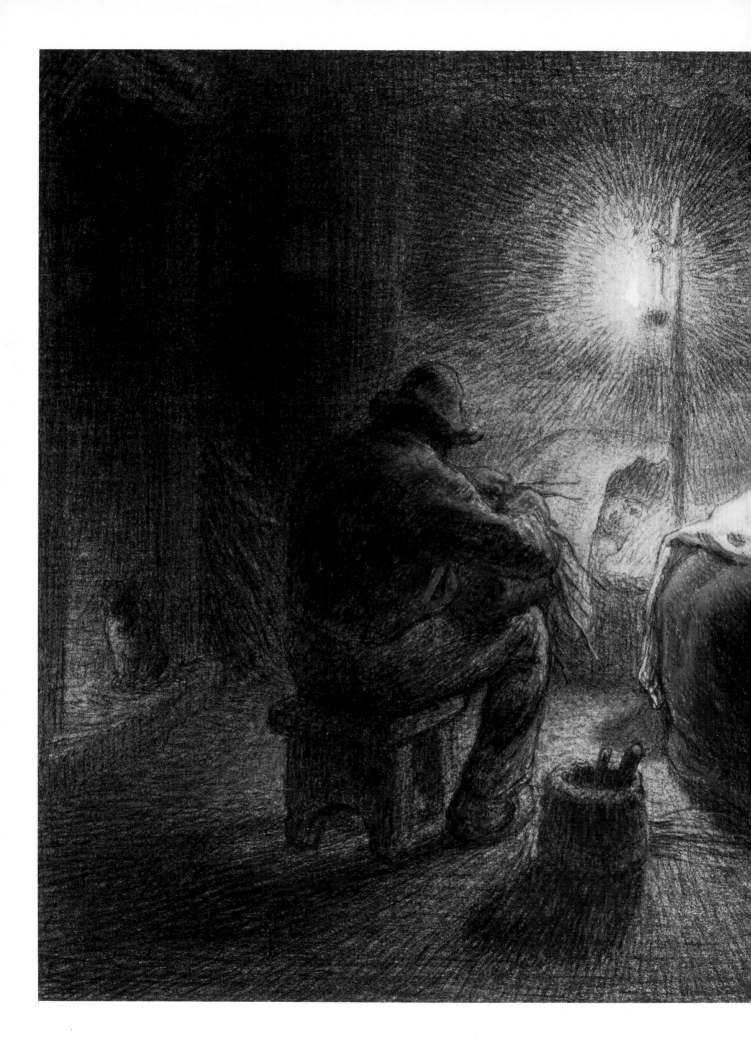

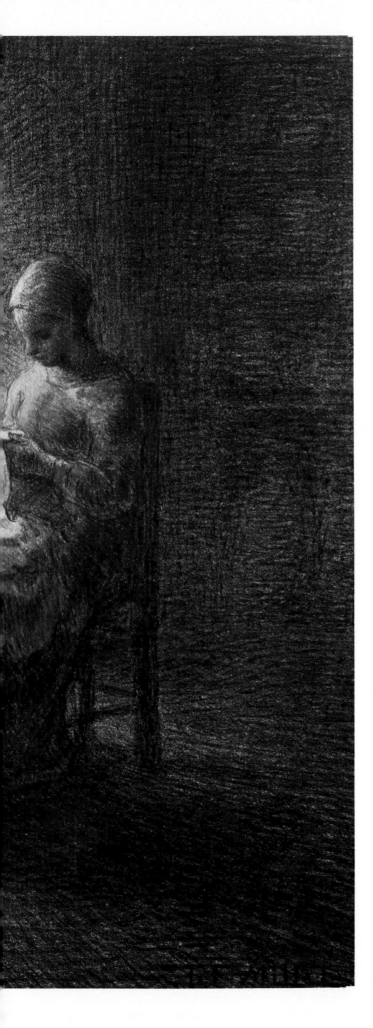

43 *Evening*

BOSTON, Museum of Fine Arts (gift of Quincy Adams Shaw). Pastel 44 × 54 cm.

For the last of the four scenes of times of the day Millet turned to drawings he had done showing a woman sewing by lamplight as she watched over her sleeping child. An example in charcoal is in the City Museum and Art Gallery, Birmingham. *Evening* can also be related to the family scene illustrated in *Family near a Window* (Plate 31) and to the studies of interiors and their dim lighting, for instance, *The Window* (Plate 49). Iconographically a biblical source lies behind this work, and it would seem that Millet set the Holy Family in the humble cottage of a Barbizon peasant. A similar mixture of genre and religious subject matter was used also by such seventeenth-century Dutch artists as Rembrandt (*The Holy Family*, Amsterdam, Rijksmuseum) and Nicolas Maes, and became increasingly popular with nineteenth-century artists, who, for instance, set the Supper at Emmaus in contemporary humble dwellings, for example Lhermitte's *Supper at Emmaus* of 1890 (Boston, Museum of Fine Arts).

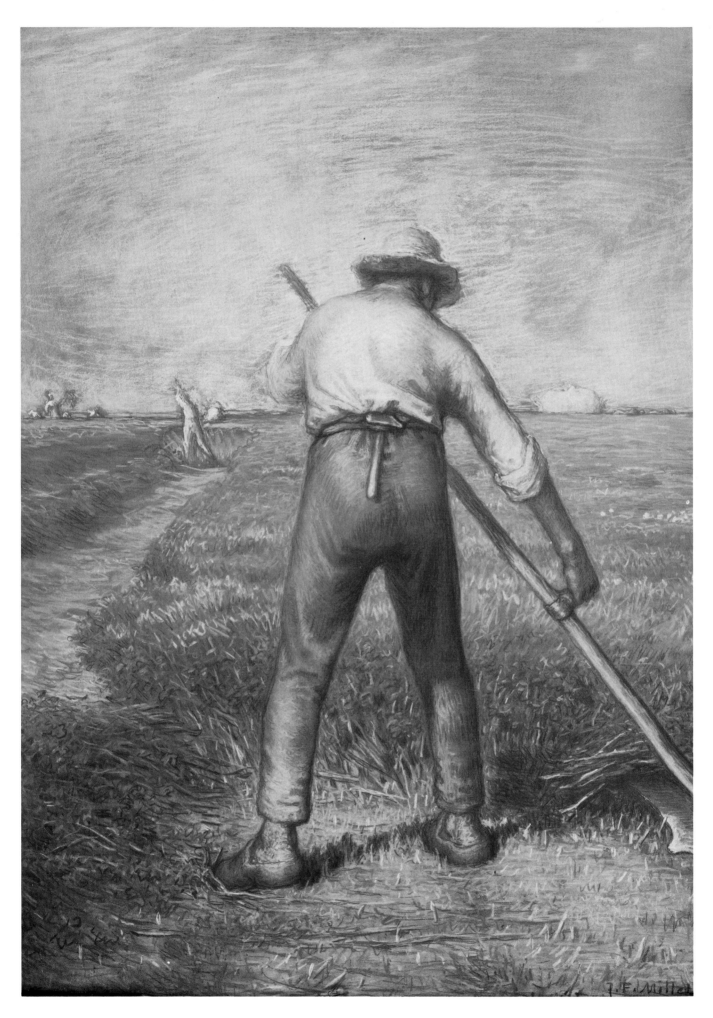

45 *The Reaper*

PARIS, Musée du Louvre, Cabinet des Dessins. Charcoal
24·5 × 17 cm.

This sketch, a study for the original drawing for an
engraving, provides a useful contrast to the Boston
Reaper (Plate 44), a pastel, for here line defines the form,
particularly in the clean contours of the massive shoulders
and long line of his left leg. In the pastel, Millet achieved
a sense of volume reminiscent of the larger oils, and the
emphasis of the drawing on the movement itself was
replaced by an interest in the substantiality of the man
himself. The characteristic style of the 1860s can be seen
in the pastel's fine network of directional strokes all over
the form. Millet addressed himself to the problem of
defining or suggesting form in many ways throughout his
artistic career, often turning to simple outlines in drawings
or thick paint and varied colours in oils. In pastel he
found a partial solution by marrying line and colour.

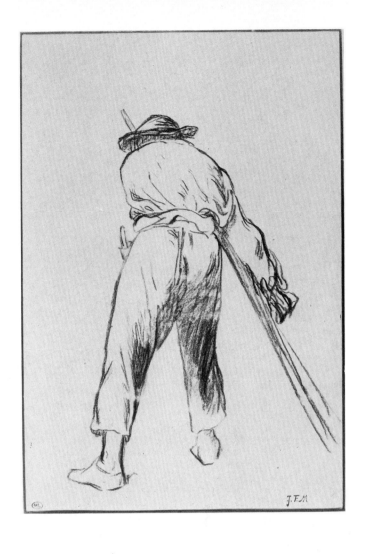

(opposite)
44 *The Reaper*
BOSTON, Museum of Fine Arts. 1866–68. Pastel and black crayon 96 × 68 cm.

Gavet also commissioned this reprise of a drawing of the reaper engraved by Lavieille in 1853 for
a longer series devoted to the twelve labours of the fields. It originated in a figure representing
Summer in an engraving by Bruegel. While looking back to sixteenth-century and late Gothic
sources, Millet's use of a series also anticipated the preoccupations of such Post-Impressionist
artists as van Gogh, Gauguin, Bernard and the Nabis.

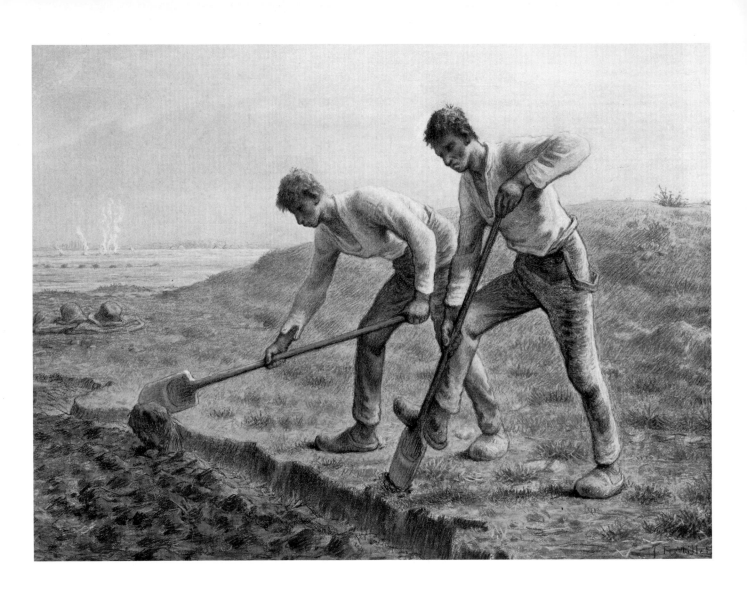

46 *The Diggers*
BOSTON, Museum of Fine Arts (gift of Quincy Adams Shaw). 1866. Pastel on yellowish paper
70 × 94 cm.

The motif of men digging, in common with so many of Millet's subjects, has a long history
beginning with a lost drawing of 1846–50 and culminating in this very large pastel drawing
bought by Emile Gavet. Millet introduced into it some of the stock items of his pictorial vocabulary,
the labouring figure (Plates 8–11 and 13), the still-life of jacket and hat (Plate 29), the distant
view (Plates 25 and III), the coloured grounds (Plates 31 and 38) and the lively line of pastel
(Plates 40–44).

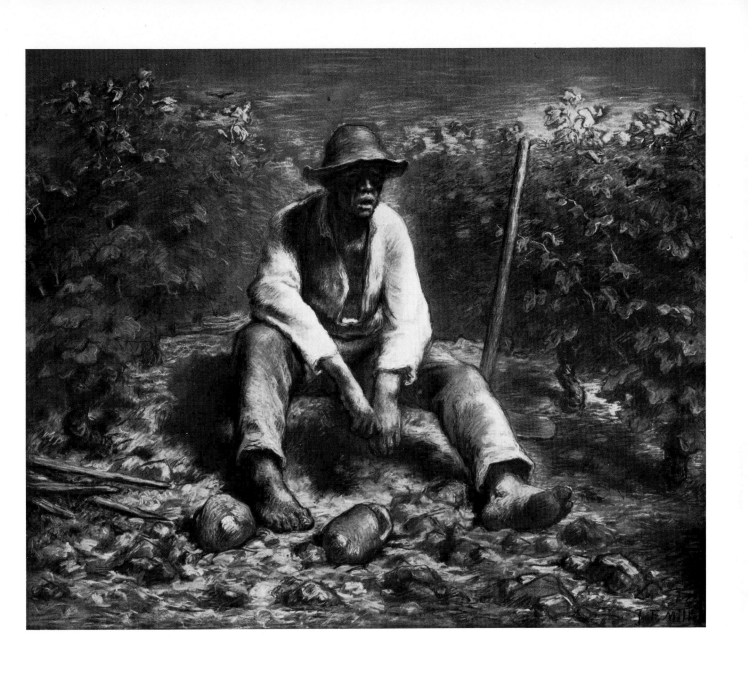

47 *The Vine Tender*
THE HAGUE, Rijksmuseum Mesdag. 1869–70. Pastel and black crayon 70·5 × 84 cm.

This last example of the Gavet pastels belongs to the genre of the *Man with the Hoe* (Plate 29) and *Death and the Woodcutter* (Plate 27). The pose was quoted almost directly by Achille d'Orsi in his sculptured monument to back-breaking labour, *Proximus Tuus* of 1880. Millet's pastel is so cheerfully coloured, with much local colour in the greens and blues, that the fatalistic element is belied by the surrounding natural beauty.

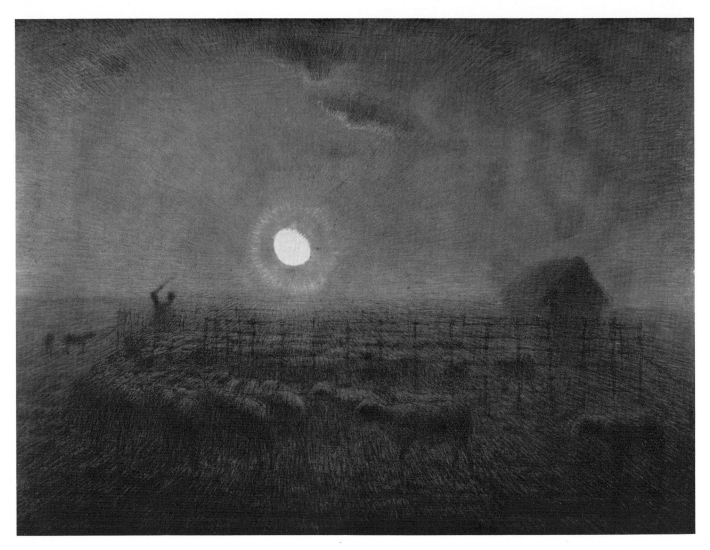

48 *The Sheepfold*

GLASGOW, City Art Gallery and Museum. 1868. Pastel
72·1 × 95 cm.

The moonlight and the subject of a shepherd encouraging
his flock into the fold for the night were made famous by
Millet's contemporary Charles Daubigny, beginning with
an etching of 1846 and later in an oil for the Salon of
1861 (The Hague, Rijksmuseum Mesdag). Millet
produced a number of variants on this theme, the earliest
of which is a painting of 1856–58 in the Walters Art
Gallery, Baltimore. This drawing, however, is not merely
a picturesque study of moonlight but also an
extraordinary artistic creation. Radiating lines pulsating
out from the near full moon and its subtle halo seem at
first sight to represent the light, but on closer examination
it is the space between the lines, which the lines
punctuate rhythmically, that is the active agent of light.
Furthermore, Millet managed to convey the forms of the
sheep and the effects of the fading light so that within the
sheepfold itself their bodies are only implied by slightly
undulating patterns of dark and light. Millet here
revealed an amazing understanding of natural effects and
of the pictorial means to convey them without pedantry
or picturesque falsification.

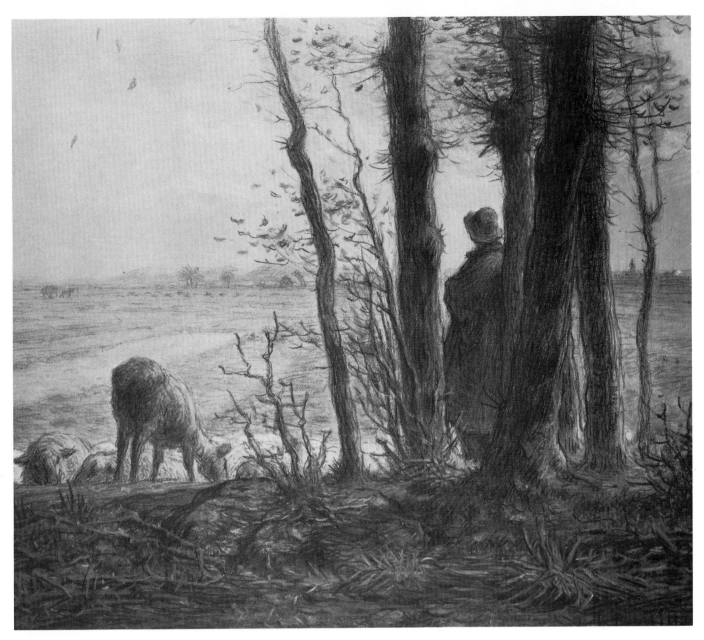

50 *Falling Leaves*
WASHINGTON, Corcoran Gallery of Art (W. A. Clark collection). 1866–67. Pastel and black crayon
on beige paper 37 × 43 cm.

This pastel is richly coloured with strong blues, greens, yellow and warm earth colours in the
foreground, and paler blues, yellows and mauves in the distant and sunlit plain. In black and white
reproduction the tonal contrasts underlying Millet's colour scheme are especially evident, for he
used a lot of white in the paler areas of the background, and black crayon was added to the
foreground colours. The radical division of the page into two areas with a decorative screen of
undergrowth and trees across the foreground was influenced by Japanese prints, particularly by
the work of Hokusai, which Millet began to collect in the 1860s. Japanese prints suggested to many
artists of the period new ways of presenting space, a concern which became important to Millet as
he turned increasingly to pure landscape in the latter part of this decade. The shepherd, that
enigmatic and mysterious personage, beloved of Millet since his earliest drawings, serves here to
carry the spectator's gaze beyond the screen of trees into the extensive landscape and to introduce
a note of contemplative melancholy, echoed in the autumnal theme.

(opposite bottom)
49 *The Window*
LONDON, British Museum, Department of Prints and Drawings. c. 1857. Black chalk 15·9 × 16·5 cm.

Black chalk was rubbed into grey-toned paper, with hints of coloured washes, to produce a simple
study of tones in a small interior against the light of the window. The importance of tonal values to
Millet was constant throughout the first three decades of his work but gave way to purer colour in
the later landscapes. This drawing was perhaps the type of exercise in values which so inspired
Georges Seurat (fig. 2), but the two baskets on the sill hint at a connection with Millet's private
symbolism, reflected also in *Going to Work* (Plate 22) and *The Angelus* (Plate III).

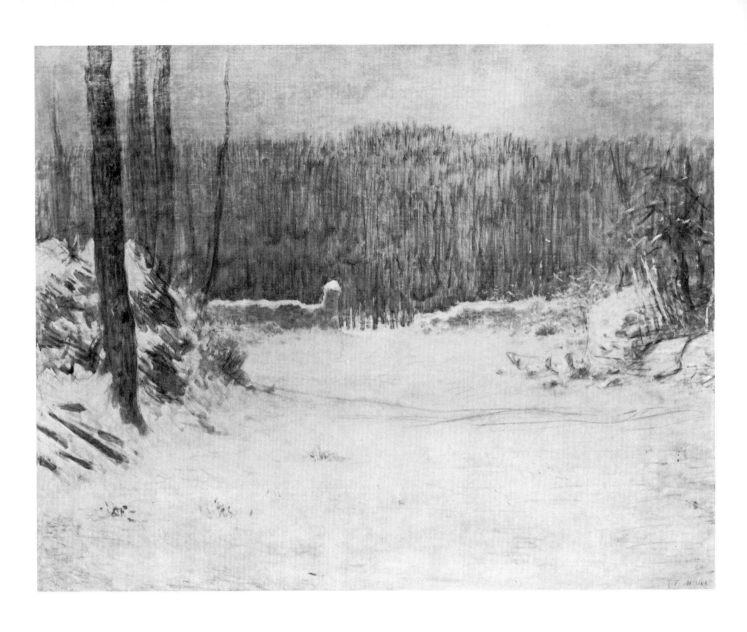

51 *The Porte aux Vaches in the Snow: Solitude*
PHILADELPHIA, Philadelphia Museum of Art. 1853. Oil on canvas 85·5 × 110·5 cm.

Théodore Rousseau, one of the artists who had settled in Barbizon during the 1840s, became
Millet's close friend shortly after his own arrival. Rousseau, a landscape painter, devoted himself to
the Forest of Fontainebleau and frequently used the device of a small clearing in the dense mass
of trees to provide the spectator with a point of entry via the central open space, and in *The Porte
aux Vaches in the Snow* Millet used a similar approach. However, the Porte aux Vaches clearing
had a special significance for Barbizon peasants, for it was through this gate that the village cowman
led the peasants' cows for a day's grazing (Wheelwright, 1876). Millet considered this canvas
unfinished, which does not diminish the appeal of its radical simplicity to a modern audience. Its
incompleteness reveals clearly Millet's use of toned grounds, in this case grey-brown, which sets the
tone for the winter chillness. Millet loved the cold, dark winters of Barbizon and wrote to Sensier
on 18 December 1866, 'I would never like to be deprived [of these sad times of year], and if
someone suggested to me that he carry me off to the South to pass the winter, I would absolutely
refuse. O sadness of the fields and woods, one would lose too much by not seeing you.' Finally it is
interesting to note the sub-title, *Solitude*, for in deathly wintertime, the earth sleeps under a blanket
of snow and man awaits the return of life in spring. Millet captured with cold colours and skeletal
bareness the feel of winter as powerfully as he celebrated the fullness of summer with warm
colours, brilliant lights and the bustle of human activity.

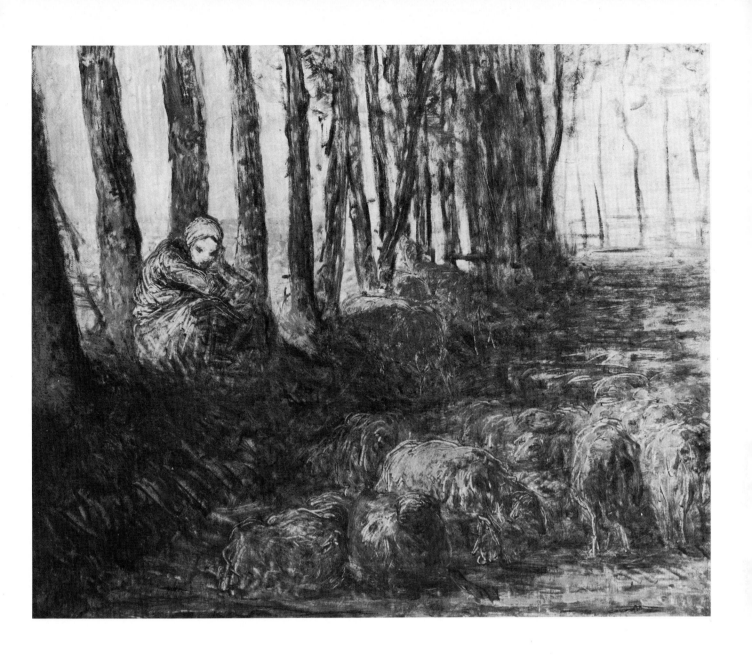

52 *The Shepherdess with a Flock*
PARIS, Musée du Louvre. Undated. Oil sketch on canvas 45 × 55 cm.

This unfinished oil sketch also reveals Millet's technique of working up a canvas layer by layer, gradually defining the particular forms after the main areas of dark and light were established. It is specially interesting to notice how Millet actually used line in the paint by working over the liquid bistre with the wooden end of his paintbrush so that the lighter ground breaks through the darker areas producing quite subtle variations of tone. The composition is also of interest for its decorative use of a line of tree trunks leading one diagonally into the space and setting up a contrapuntal rhythm of dark and light across the canvas.

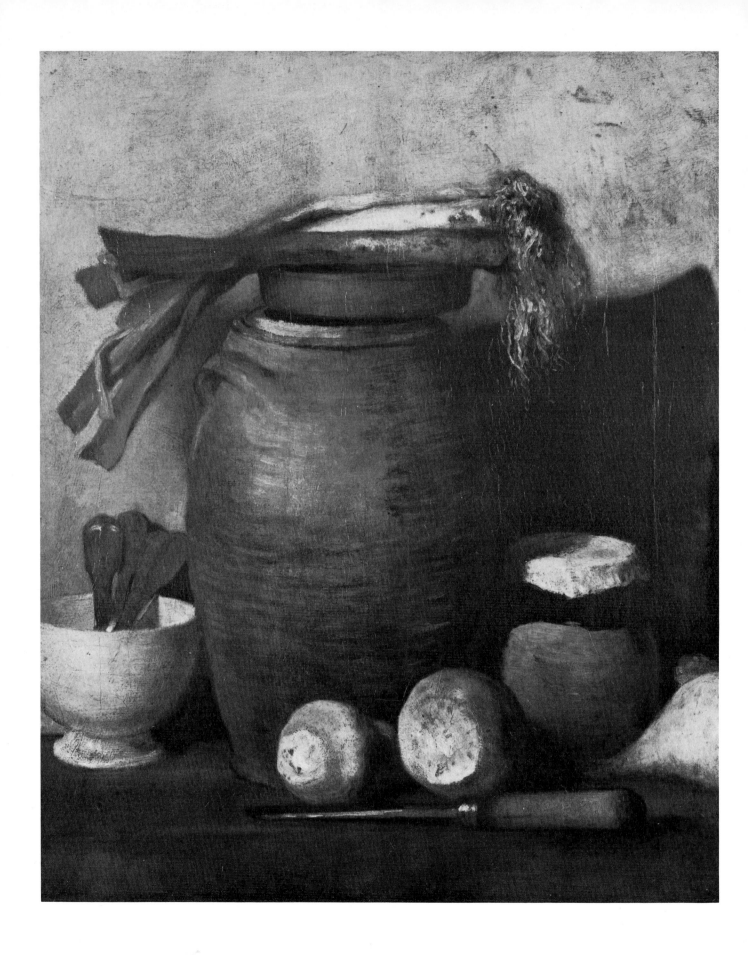

76

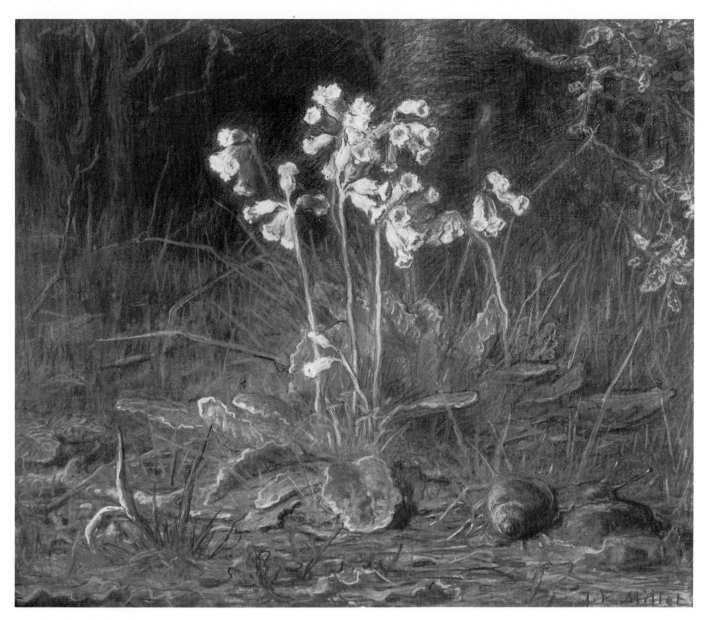

54 *Cowslips: Spring Flowers*
BOSTON, Museum of Fine Arts (gift of Quincy Adams Shaw). 1867–68. Pastel 40×48 cm.

In direct contrast to the breadth and grandeur of Millet's landscapes, this living still-life offers a microscopic view of a tiny section of nature, revealing a lesser known aspect of Millet, a simple joy in nature's beauty. He is quoted as observing, 'There are those who say that I deny the charms of the countryside; but I find there more than charm, infinite splendours. . . . I see very clearly the haloes round the dandelions, and the sunlight that shines down there. . . . ' In this pastel one is reminded of the works of the English Pre-Raphaelites, particularly of John Everett Millais's *Ophelia* (London, Tate Galley), which was exhibited in France in 1855. In a painting of *Irises* (New York, private collection, 1889) Vincent van Gogh, who had probably seen Millet's pastel in the Gavet sale of 1875, also celebrated the infinite splendours of the particular and often overlooked corners of nature. Millet's use of pastel here is dense, colourful and lively.

(opposite)
53 *Still-life with Leeks*
THE HAGUE, Rijksmuseum Mesdag. c. 1860. Oil on canvas 75×61 cm.

Very few still-lifes by Millet are known. The Musée National des Beaux-Arts in Algiers owns one with a similar earthenware pot and turnips, dated 1868, and there is one other in Boston. The *Still-life with Leeks* is remarkable for its size, and it is characteristic of Millet to have composed this simple collection of culinary objects with superb proportions that achieve a kind of monumentality. Its source perhaps lies in the work of the French eighteenth-century still-life painter, Chardin (1699–1779), whose works figured largely in the exhibition of eighteenth-century paintings at the Bazar Bonne Nouvelle in 1848.

55 *The Porte aux Vaches in the Snow*
PARIS, Musée du Louvre, Cabinet des Dessins. 1853.
Black crayon, stump on beige paper 28·2 × 22·5 cm.

Although this drawing depicts the same site as Millet
painted in 1853 (Plate 51), the viewpoint of the artist is
closer to the cow gate. The diminutive size, however, of
the hunter and his dog gives the drawing bigger scale.
The dense curtain of trees closing off the scene at the
back and the row on the left appear taller and more
imposing, while the rich blacks of the trees make the
snow appear more brilliant. It is remarkable how Millet
created a sense of the forest by varying the density of the
black lines and touching them here and there with
irregular dashes which prevent them appearing too flat
and suggest infinite recession into the heart of the
brooding forest.

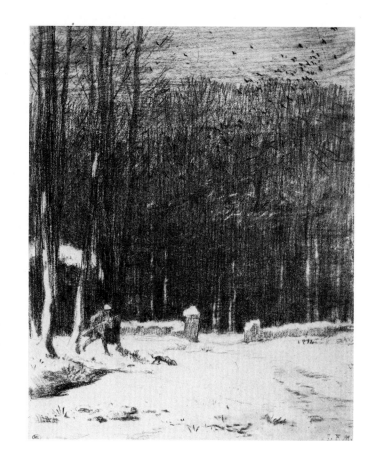

(opposite)
VII *Autumn Landscape with a Flock of Turkeys*
NEW YORK, Metropolitan Museum of Art (bequest of Isaac D. Fletcher). 1872–73. Oil on canvas
81 × 99·1 cm.

A melancholic mood dominates this brooding image of autumn. In composition it recalls an earlier
drawing, *Falling Leaves* (Plate 50), with its denuded trees and a sombre silhouette of a figure gazing
into the distance. It shares too the decorative quality of that pastel in three solid masses, seen
against the light and ranged in parallel along a plane from which the landscape dips suddenly into
a luminous beyond. The device of a dark foreground and a brilliantly lit distance echoes the work
of the seventeenth-century Dutch painter Jacob Ruysdael, whose *Sunlight* was in Millet's lifetime
(and still is) in the Louvre. Ruysdael was presented by such nineteenth-century writers as Millet's
friend Théophile Thoré as a painter of melancholy. Evident in Millet's autumnal image is the
flowering of his palette, its warm browns dotted with brilliant reds on the turkeys' necks, contrasting
with the lighter pinks, mauves and grey-blues of the landscape and clouds, all of which have been
revealed by recent cleaning. The enigmatic shepherdess, the leafless tree, the bushy stack, the
abandoned plough and harrow bring together in one work all those expressive elements of rural life
which Millet endowed with such precise historical significance and evocative power.

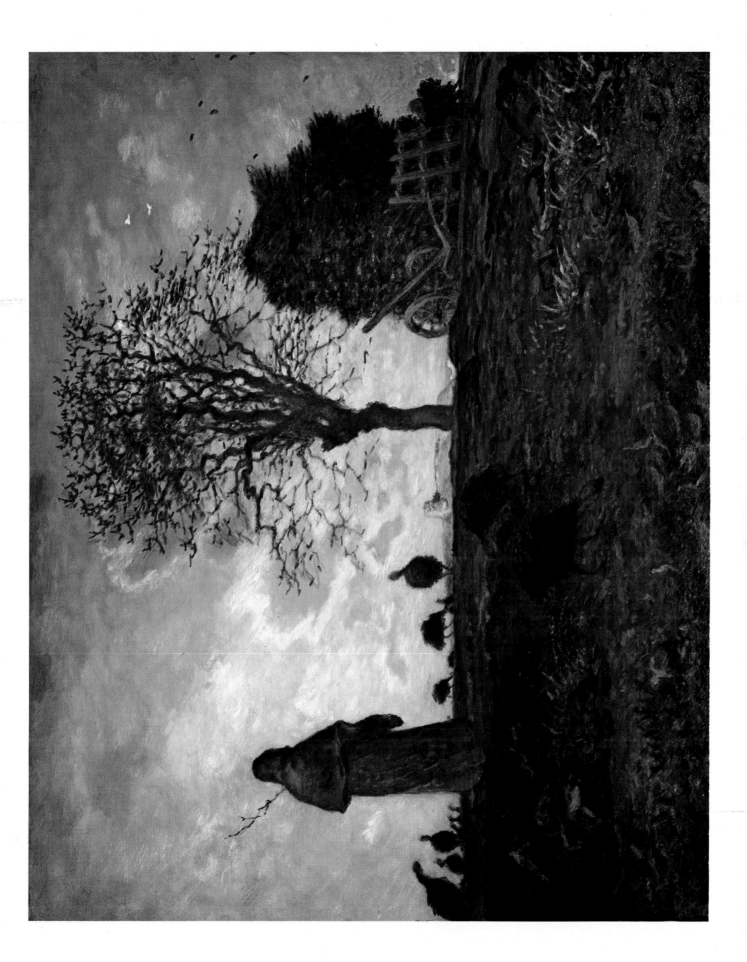

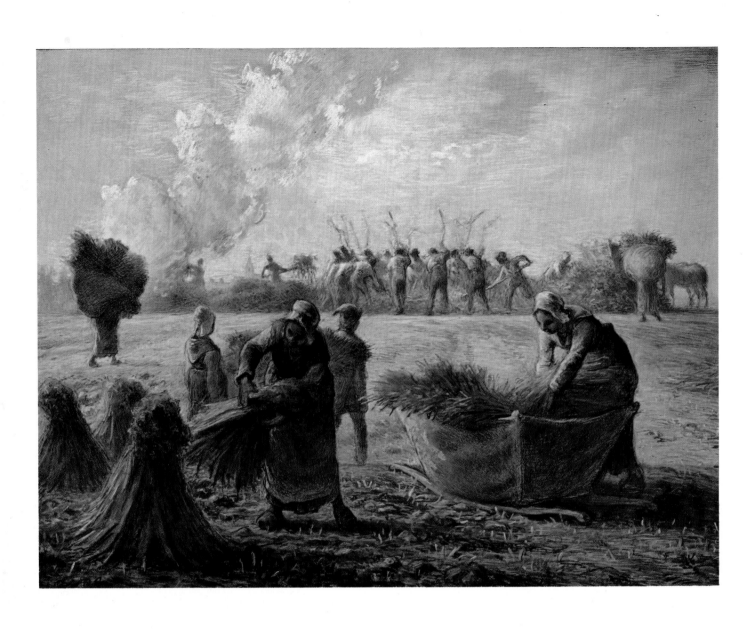

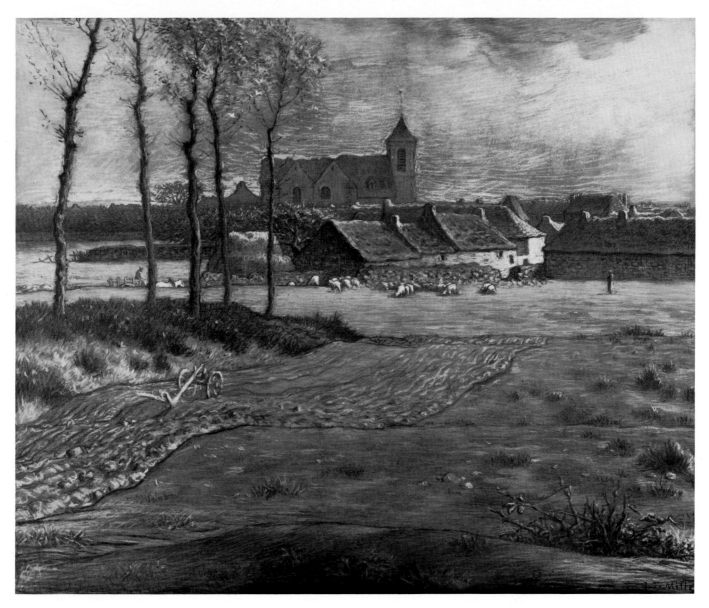

56 *The Church at Chailly*
MINNEAPOLIS, Minneapolis Institute of Arts (bequest of Mrs. Egil Boeckmann). 1860. Pastel
72·3 × 85 cm.

In this richly coloured and textured pastel, Millet introduced a number of details which can be
found in the later landscape works, the screen of trees (Plates 50 and 52), the church (Plate VI),
the plough (Plates V and 57) and the squat and solid cottages (Plate 64). By juxtaposing the village
with its dominating church and the ploughed fields Millet presented a portrait of the whole
agricultural community.

(opposite top)
VIII *Summer, the Buckwheat Harvest* (see caption to Plate 69)
BOSTON, Museum of Fine Arts (bequest of Mrs. Martin Brimmer). 1867–68. Pastel 73 × 95 cm.

(opposite bottom)
IX *Summer, the Buckwheat Harvest* (detail of Plate 69)
BOSTON, Museum of Fine Arts (gift of Quincy Adams Shaw). 1868–74. Unfinished oil on canvas
85 × 111 cm.

57 *November*
PARIS, Musée du Louvre, Cabinet des Dessins. 1868–69. Black crayon on beige paper 13·2 × 20·5 cm.

This drawing is the study for an 1870 painting of the subject of November, now lost. The lines
of the crayon reveal the dynamic energy that underlies the more finished works, such as Plate V.
Later artists adopted the qualities apparent in this swift compositional sketch, making aesthetic
virtue of the patterns of line themselves.

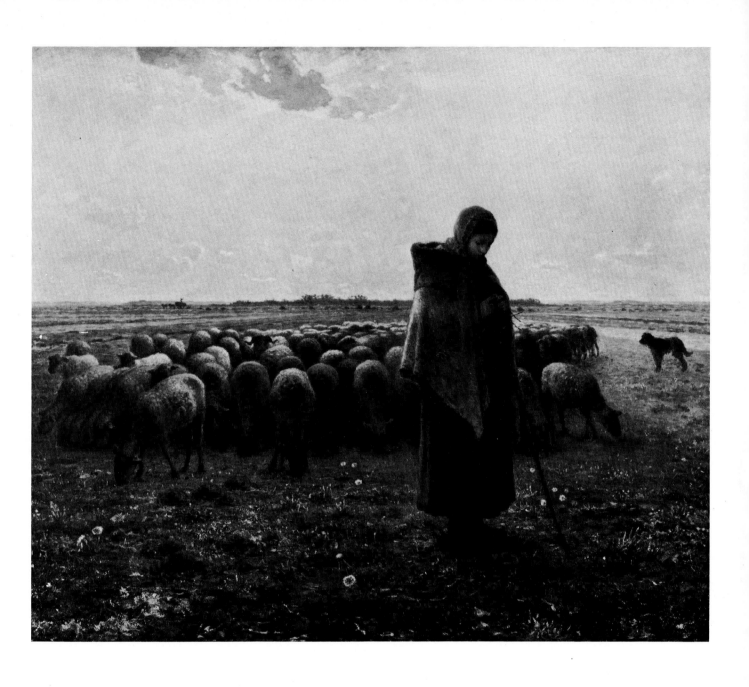

58 *The Shepherdess Guarding her Flock*
PARIS, Musée du Louvre. 1862–64. Oil on canvas 81 × 101 cm.

The colour, the calm and the almost pretty shepherdess seduced the public when the painting was exhibited in 1864 and the state offered to buy it. In reporting the success of the painting to Millet, Sensier tried to encourage the artist to paint more idyllic subjects and significantly suggested that Millet produce real versions of subjects that George Sand had treated idealistically. Despite the saccharine qualities of the subject which at that time so appealed to public taste and which were subsequently responsible for Millet's fall from critical grace, this painting has undoubted appeal in the superb colour and luminous landscape. The extensive plain of Chailly and the detailing of the flowers to be seen in, for instance, *Winter with Crows* (Plate V) and *Cowslips* (Plate 54) have been dressed up perhaps for exhibition with the addition of the picturesque shepherdess and her flock, but that does not disguise the genuine inspiration of the 'charms and splendours of nature' that Millet observed around him.

59 *The End of the Village at Gréville*
BOSTON, Museum of Fine Arts (gift of Quincy Adams Shaw). 1865–66. Oil on canvas 81·5 × 100 cm.

Millet's feeling for his native Normandy was revived by visits during the 1860s, and this painting is one of many in which childhood memories were recaptured. The comfortable solidity of the house on the left lies in shadow, and we are swept by the road towards the arc of the tree and out into the intense blue of the sky and quiet sea beyond. The spaciousness that lies beyond the tree is balanced by the delightful details of domestic life in the farmyard, the geese and the mother tenderly holding her child while it clasps the tree. The colour key is higher and seems more vibrant by virtue of the dabs and dashes with which the paint was applied. Herbert (1976) quotes a revealing letter Millet wrote to Silvestre in 1868 in which it is clear that Millet identified himself with the child, writing 'I would really like to be able to make the spectator dimly aware of what must enter for life into the mind of a child who only received impressions of that kind and later finds himself out of his element in noisy surroundings.'

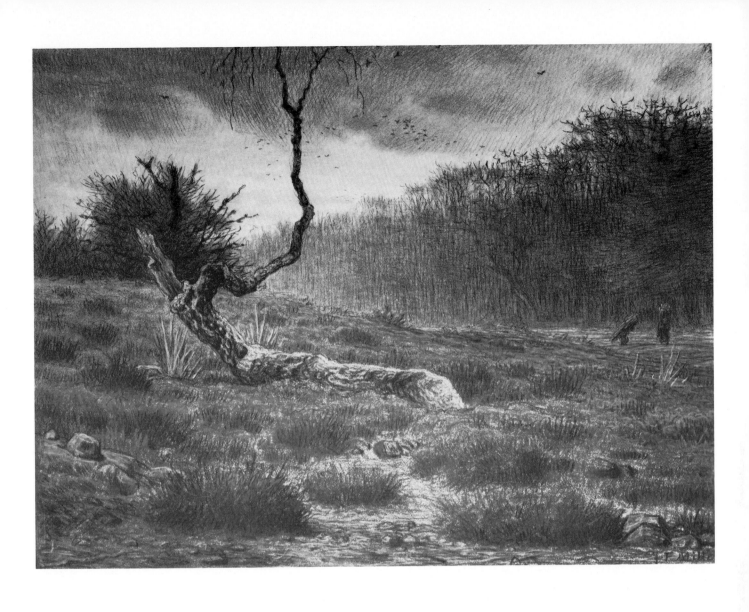

60 *The Dead Birch Tree: Forest of Fontainebleau*
DIJON, Musée des Beaux-Arts (donation Granville). 1866–76. Pastel 48×62 cm.

At first glance, this pastel seems to be a study of a forest clearing, possibly influenced by the work of Théodore Rousseau, who so frequently painted them, but also indebted to seventeenth-century landscapes by Jacob Ruysdael and Wynants. The theme of a dead tree has a long history in the veiled symbolism of landscape painting, comparable to that of the skull as a *memento mori* in still-lifes. Millet, however, added two tiny figures crushed under the weight of their enormous faggots, made up of branches of dead trees like the one that lies so boldly across the foreground.

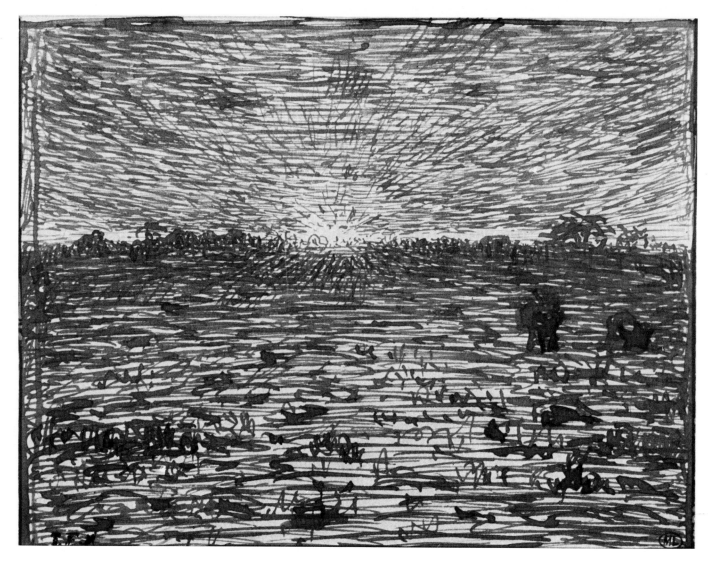

61 *The Plain at Sunset*
PARIS, Musée du Louvre, Cabinet des Dessins. c. 1869. Ink 20·6 × 19·5 cm.

This small sketch for a sunset scene is typical of Millet's work at this period. There are two interesting features, the use of pen and ink which relates to the landscapes produced under Japanese influence after 1866, as in *The House at Dyane* (Plate 62) and *The Plateau Rocks at Monaux* (Plate 63), and the thicker line that borders the paper, framing the composition. Millet is known to have painted frequently with a frame round the canvas, a practice learnt from the Dutch.

(opposite top)
62 *The House at Dyane*
OXFORD, Ashmolean Museum (bequest of Grete King). 1866. Brown ink and pencil 23·5 × 17·5 cm.

In 1866 Millet took his wife to Vichy for her health and executed a number of drawings in ink of the region. Herbert (1976) argues that this trip contributed to Millet's orientation towards landscape thereafter. Pencil lines establish the main elements of the tree trunks, the clumps of foliage and the silhouette of the cottage. The clean lines of the pen on the trunks and the pattern of marks indicating the leaves are reminiscent of Japanese prints and drawings by Hokusai. The view behind the house is closed by a single line which marks the shoulder of a hill, and the one branch of the tree fills up the 'V' of space to create an overall decorative surface which is also characteristic of the Japanese.

(opposite bottom)
63 *The Plateau Rocks at Monaux*
PARIS, Musée du Louvre, Cabinet des Dessins. 1866. Brown ink and pencil 19·9 × 25·7 cm.

After his stay at Vichy Millet visited the Auvergne, from which this view was taken. Japanese influence can also be cited in connection with this landscape in the rising ground with the horizon being the highest point on the paper. The receding planes are marked off with a solid line and the intervening spaces detailed by a variety of graphic marks, dashes, squiggles, dots etc. Millet noted in pencil the colours of certain areas suggesting that he intended to make a painting from this summary sketch. In such drawings as this, one sees again the debt van Gogh owed Millet when he came to draw southern landscapes in parallel planes enlivened by almost abstract graphic systems.

Dyane Dyane

la Plate roche de Moreau

87

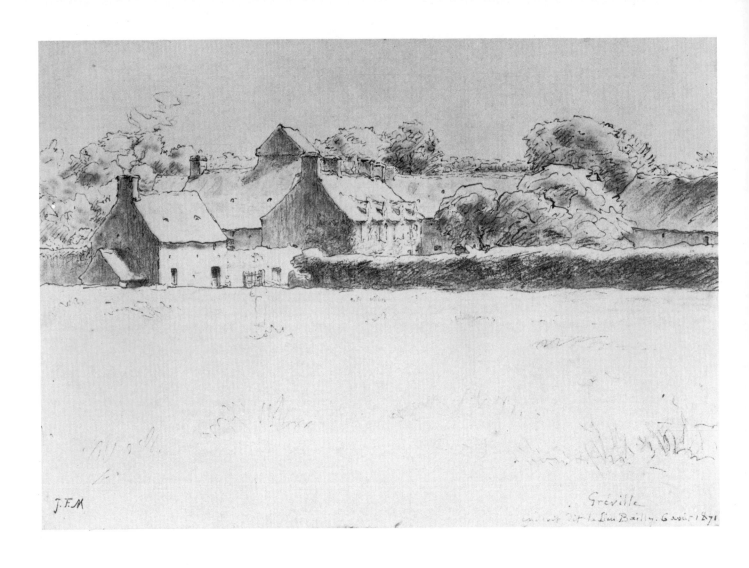

64 *Le Lieu Bailly Gréville*

OXFORD, Ashmolean Museum (bequest of P. M. Turner). 1871. Brown ink wash and coloured chalk
17·8 × 25·5 cm.

This sketch, executed in 1871 on a visit to Normandy, is a plan for a projected painting which
Millet never undertook. As with his landscapes of Vichy and the Auvergne, Millet started with a
low viewpoint and built up the surface of the page. Almost half the available area is blank except
for a few schematic indications of grass. The top quarter of the page is also relatively unmarked. By
contrast, the solid horizontal band of the masonry and trees appears immensely substantial and
monumental, further emphasized by the use of washes and coloured chalks in addition to the
linear patterns that were used in the drawings of 1866 (Plate 63). In this novel approach to
landscape Millet seems to have found successfully the means to convey his childhood memories, and
their symbolic associations for the uprooted peasant, creating a child's sense of scale in the extent
of space to be traversed in the foreground and the imposing contrast of the welcoming security of
the farm buildings beyond. One is reminded of Adrian Stokes's psychoanalytic insights into the
symbolism of architecture which he associates with ideas of the Mother. In Millet's work there is
a parallel between the solid volumes and full forms of his women and the qualities attributed in this
drawing to the buildings and their surrounding trees.

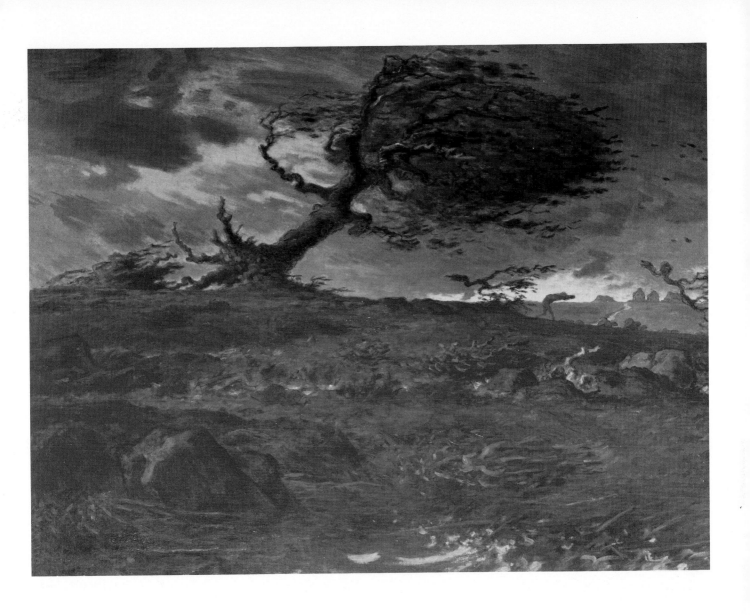

65 *The Windstorm*
CARDIFF, National Museum of Wales. 1871–73. Oil on canvas 90 × 117 cm.

After the pastoral peace and solid security of the scenes at Gréville (Plates 64 and VI), this dramatic study of the destructive power of natural forces is all the more striking. There is a small sketch for the painting in the Louvre, made up of swirling lines and focusing mainly on the tree itself. In the oil, Millet added the distant plain with a snaking path leading to the group of buildings on the horizon and the tiny wind-blown figure whose insignificance and powerlessness give the tree its huge scale. In painted landscapes of the 1870s Millet used the format of the Vichy drawings, building up the plane of the canvas to a high central point so that the middle distance, here the brow of the hill marked by the huge tree, is also the middle of the flat surface of the canvas. That and the decorative treatment of the tree suggest Japanese prints as a source, but *The Windstorm* may also have been derived from the landscapes with wind-blown trees by Théodore Rousseau, who at the same period incorporated elements of Japanese art into his own work.

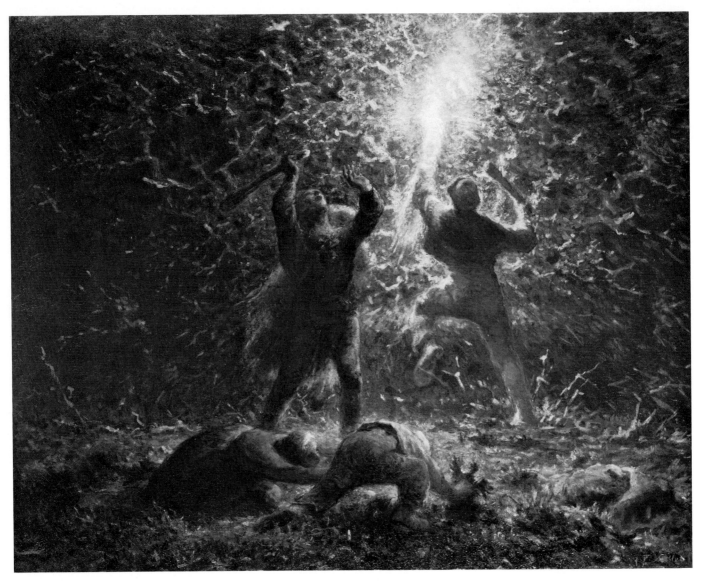

(top)
66 *The Birdnesters with Torches*
PHILADELPHIA, Philadelphia Museum of Art. 1874. Oil on canvas 73·5 × 92·5 cm.

This strange nocturnal scene is a riot of paint, liberated from all constraint to flow and leap across the canvas in rich patterns. Thick impasto in the centre indicates the brilliant and fiery light of the torch, and the way its light breaks through the darkness is represented on canvas by the way in which the yellow paint itself was spread in rhythmic strokes across the surface, touching the figures.

Will H. Low, an American visitor, recorded a conversation with Millet about the origins of the subject of this picture. 'When I was a boy there were great flights of wild pigeons which settled in the trees at night, when we used to go with torches and the birds blinded by the light could be killed by their hundreds with clubs.' 'And you have not seen it since you were a boy?' 'No, but it all comes back to me as I work.' Herbert (1976) sees in this painting a visionary composition and wonders whether, in the murderous ritual of the demoniacal and contorted figures and hellish light, there is not a premonition of death and an image of the harshness of life, for Millet's health had been failing steadily and he lived only one month into 1875.

(left)
67 *Study for 'The Birdnesters'*
BAYONNE, Musée Bonnat. Crayon 26·4 × 37·2 cm.

A dozen sketches for the painting are known including three in the Louvre, one in Indianapolis and this study of the figures who seem engaged in some ritual dance. The dancing line that captures the energy of the figures does not describe their form and instead recalls the early drawings for subjects such as the *Woodsawyers* (Plates 10 and 11). The compressed pose of the crouching figure in this study also looks back to the woodcutter on the left of the painting of *Woodsawyers*, in which Millet caught a configuration of the body that absolutely expresses its action.

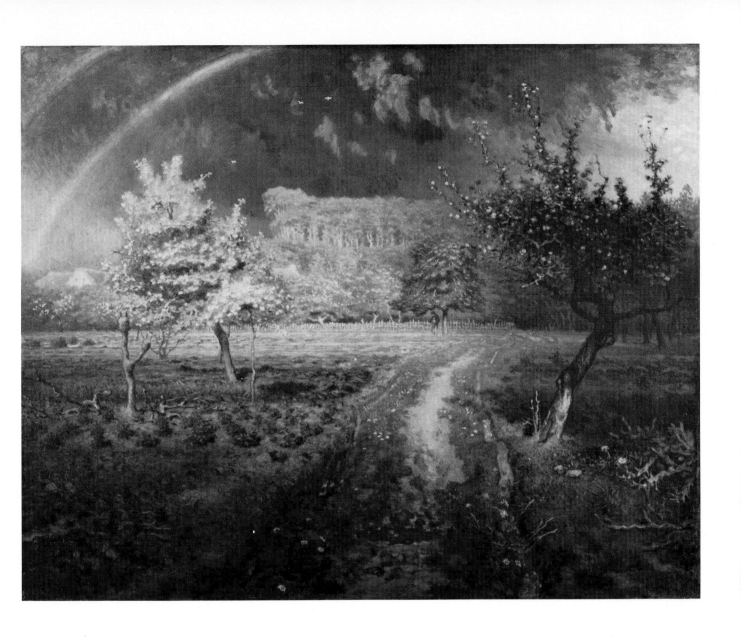

68 *Spring*
PARIS, Musée du Louvre. 1868–73. Oil on canvas 86 × 111 cm.

In 1868 Millet began the last great cycle of his life with four canvases representing the four seasons for Frédéric Hartmann. In these the preoccupations and patterns underlying his life's work were drawn together in paintings of glorious and stunning colour. *Spring* is the purest landscape, but a tiny figure shelters under a distant tree from the passing storm, conveyed by Millet through the rainbow and most remarkably in the strange brilliance that emanates from the deep blue sky. The blossoming trees look back to Japan and anticipated the great series painted by van Gogh in Arles in 1888 shortly after having seen Millet's *Spring* at the 1887 retrospective in Paris. We are led into the landscape by the path that opens out invitingly in the foreground toward the tiny figure placed almost centrally in the middle distance and are invited to place ourselves in nature, the arching rainbow creating a canopy of space over the landscape. Rich and jewel-like colour celebrates the life and the promise of the earth's fertility.

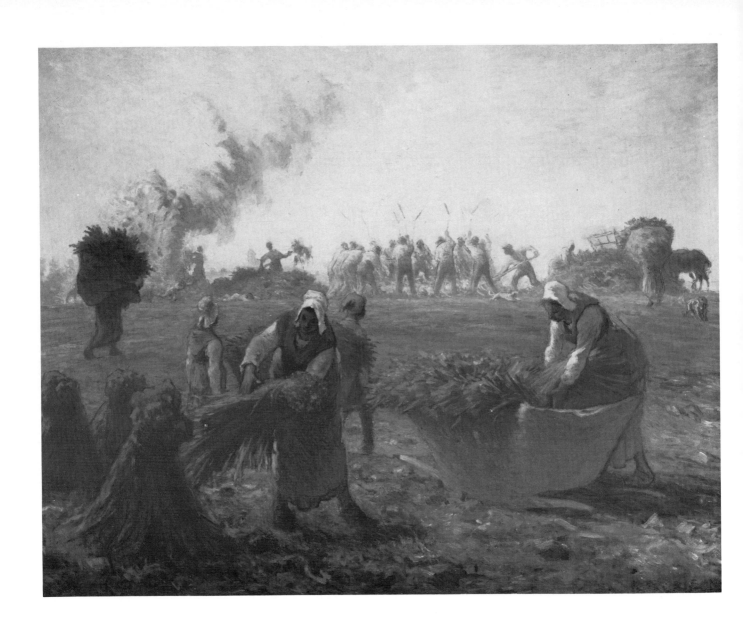

69 *Summer, the Buckwheat Harvest* (see Plates VIII and IX)
BOSTON, Museum of Fine Arts (gift of Quincy Adams Shaw). 1868–74. Unfinished oil on canvas
85 × 111 cm.

The pastel (Plate VIII), once again executed for Emile Gavet, was reworked in oil as the second of
the series of four seasons for Millet's other important patron, Hartmann. The peasants harvesting
buckwheat was a Normandy scene and a childhood memory. Millet seems to have brought forward
the harvesters in the middle distance of *The Gleaners* (Plate 25). The monumental and traditionally
composed qualities of 1857 gave way in *Summer* to a format that involves the spectator in the
peasants' work. This is even more marked in the oil version in which the frame severs the left-hand
sheaves more sharply, but in both oil and pastel, the high horizon is closed off by the figures and
wagons of the distant group whose energetic gestures recall the violence of *The Birdnesters* (Plate
66). The burning heat of the sun is almost palpable as the yellow of the ground breaks through all
the thin layers of pastel or paint. By comparing the two one can appreciate how the exercises in
pastel liberated Millet's work in oil, and in the painting of 1868–74 he successfully overcame the
restraints of traditional landscape composition and tonal modelling in the way the composition
could expand beyond its frame and by the use of colour in which the pervasive luminosity of the
ground evokes the substance of light, heat and atmosphere in an almost synaesthetic experience.

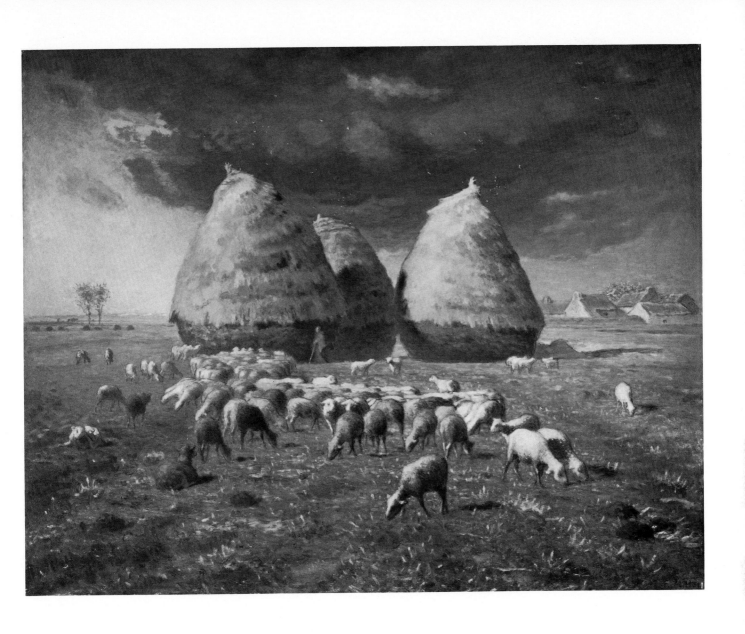

70 *Autumn*
NEW YORK, Metropolitan Museum of Art (bequest of Lillian S. Timken). 1868–74. Oil on canvas
85 × 110 cm.

While cottages nestle close to the ground as if they grew out of it in the distance on the right, the
great stacks stand with monumental dignity like some towering cathedral in the centre, and in their
shadow is the haunting figure of the little shepherdess, her sheep spread out towards us. In many
places the bright pink ground breaks through, and it is this colour that is responsible for the superb
effects of autumnal light, the real subject of this scene. Millet's seasons have been demonstrated
again and again to go back to the northern tradition of devotional books in which scenes from
agriculture were used to punctuate the Christian calendar, but in this last series of seasons the
figurative element was sacrificed, and the environmental qualities of landscape and weather
dominate with a physical insistence. Space and light are sensationally real.

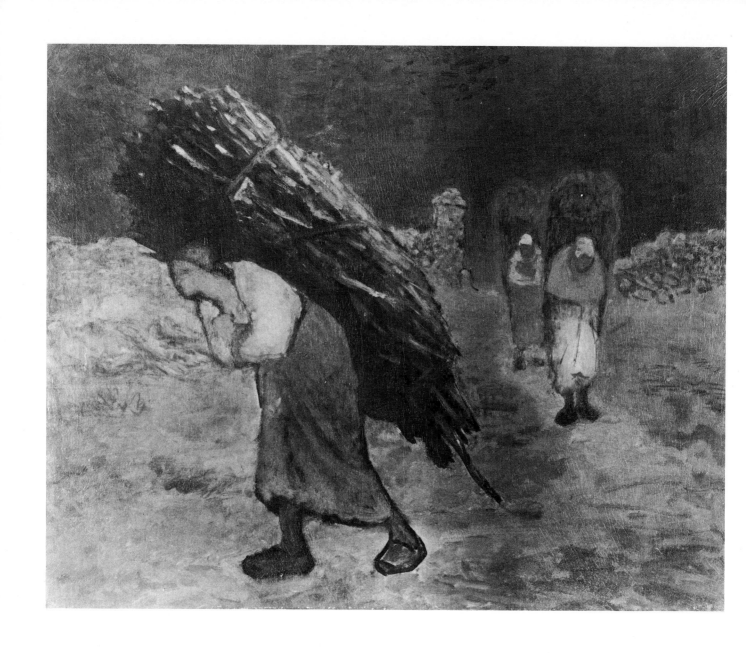

71 *Winter*

CARDIFF, National Museum of Wales. 1868–74. Unfinished oil on canvas 78·7 × 97·8 cm.

It is appropriate that this cycle should end with winter and in nature's death the dying Millet returned to the dominant figure. The slight faggot gatherers of 1863 (Plate 39) achieved the monumentality of *The Sower* of 1850 (Plate 19), but bent, aged and burdened by their enormous faggots, they are here eloquent of the condition of man, weariness. A weak yellow conveys the pale and cold light of winter as powerfully as its rich counterpart suggested the burning heat of the opposing painting and season, *Summer* (Plate 69). In Millet's *oeuvre*, man and nature are engaged, through work, within a rhythm of the seasons in an endlessly repeating cycle. Throughout his life Millet struggled to find in the forms of art available to him the means to express not only his sense of interdependence and the cyclical nature of time, but also his conviction that life was hard and wearisome although nature offered consolation, not solely in its fruitfulness and splendour but additionally in its elemental force. In the last series of the four seasons, which preoccupied him in his final years, we can see the resolution of his struggle to make art convey the peasant consciousness that the industrial, urban society has almost destroyed.

Bibliography

Bachelard, G., *La terre et les rêveries de la volonté*. Paris, 1948.

Bacou, R., *The Drawings of Jean-François Millet*. Paris and London, 1976.

Barbizon Revisited, Museum of Fine Arts, Boston, exhibition catalogue, 1962.

Benedite, L., *The Drawings of Jean-François Millet*. London, 1906.

Berger, J., 'Millet and a Third World', *New Society*, 29 January 1976.

Bouret, J., *The School of Barbizon*. London, 1972.

Cartwright, J., *Jean-François Millet, his Life and Letters*. London, 1906.

Cartwright, J., 'The Drawings of Jean-François Millet in the collection of Mr. James Staats Forbes', *The Burlington Magazine*, 1904, 1905.

Chesneau, E., 'Jean-François Millet', *Gazette des Beaux-Arts*, May 1875.

Clark, K., *The Romantic Rebellion*. London, 1973.

Clark, T. J., *The Absolute Bourgeois, Artists and Politics in France, 1848–51*. London, 1973.

Clark, T. J., *The Image of the People*. London, 1973.

Dali, S., 'Interprétation paranoïaque-critique de l'image obsédante de Millet', *Minotaure*, 1933.

Dali, S., *Le mythe tragique de L'Angélus de Millet*. Paris, 1963.

De Forges, M. T., *Barbizon*. Paris, 1962; new edition, 1971.

Delteil, L., *Le peintre-graveur I: J. F. Millet et Théodore Rousseau* Paris, 1906.

Dorbec, P., *L'art du paysage en France*. Paris, 1925.

Durbé, D. and Damigella, A., *La scuola di Barbizon*. Milan, 1969.

Haskell, F., 'Millet in London and Paris', *The Burlington Magazine*, May 1976.

Herbert, R., 'Millet Revisited', *The Burlington Magazine*, July and September 1962.

Herbert, R., 'Millet Reconsidered', *Museum Studies*, 1966.

Herbert, R., 'City vs Country: The Rural Image in French Painting from Millet to Gauguin', *Art Forum*, February 1970.

Herbert, R., 'Les Faux Millet', *Revue de l'Art*, 1973.

Herbert, R., 'Le naturalisme paysan de J. F. Millet hier et aujourd'hui', essay in catalogue *Jean-François Millet*, Paris and London, 1975–76.

Jean-François Millet, Petit Palais, Paris, and Arts Council, London, exhibition catalogue, 1975–76.

Lepoittevin, L., *Centcinquième anniversaire de la naissance de Jean-François Millet*. Cherbourg (Musée Thomas Henry), 1964.

Lepoittevin, L., *Millet I: portraitiste*. Paris, 1971.

Lepoittevin, L., *Millet II: l'ambiguïté de l'image*. Paris, 1973.

Lindsay, K., 'Millet's Lost Winnower Rediscovered', *The Burlington Magazine*, May 1974.

Markham, E., *The Man with the Hoe*. San Francisco, 1899.

Michel, A., 'J. F. Millet et l'exposition de ses oeuvres à l'École des Beaux-Arts', *Gazette des Beaux-Arts*, July 1887.

Moreau-Nélaton, E., *Millet raconté par lui-même*, 3 vols. Paris, 1921.

Naegely, H., *J.-F. Millet and Rustic Art*. London, 1898.

Nochlin, L., *Realism*. London, 1970.

Raphael, M., *The Demands of Art*. London, 1968.

Roger-Milés, L., *Le paysan dans l'oeuvre de J.-F. Millet*. Paris, 1895.

Sensier, A., *Jean-François Millet, paysan et peintre, sa vie et ses lettres*. Paris 1881; English translation by E. de Kay, 1880 (sic).

Serullaz, M., 'Van Gogh and Millet', *Etudes de l'Art*, 1950.

Sloane, J. C., *French Painting between Past and Present*. Princeton, 1955.

Thomson, D. C., *The Barbizon School of Painters*. London, 1890.

Tomson, A., *Jean-François Millet and the Barbizon School*. London, 1905.

Wheelwright, E., 'Personal Recollections of Jean-François Millet', *Atlantic Monthly*, September 1876.